Wildlife
Photographer of the Year
Highlights Volume 3

Published by the Natural History Museum, London

Front cover: **Snow spat by Erlend Haarberg**
Finalist: Black and White Category

As spring comes to Norway's upland birch forests, tension grows between mountain hares. Under cover of darkness, they become more active, fighting over females and food. Erlend spent many springs and countless freezing nights in a hide, waiting for their company and watching their antics. Prey for predators, including humans, the hares were always cautious, but they did get used to the camera clicks. He put out food to attract them closer and illuminated the area with lamps, which didn't seem to bother them (they moved in and out of the light with confidence). Months of work came together one night in heavy snow, when two individuals started squabbling over food. Snowflakes flying, Erlend froze the action, capturing the rivals' postures perfectly balanced and backlit. Converting his image to black and white accented the drama of this unique moment.

Nikon D800E + 300mm f2.8 lens; 1/1600 sec at f2.8; ISO 3200; Gitzo tripod + UniqBall head; two 1000W lamps.

First published by the Natural History Museum, Cromwell Road, London SW7 5BD
© The Trustees of the Natural History Museum, London, 2017
Photography © the individual photographers 2017

ISBN 978 0 565 0 94164

A catalogue record for this book is available from the British Library.

10 9 8 7 6 5 4 3 2 1

Competition and winners captions editor: Rosamund Kidman Cox
Winners caption writers: Tamsin Constable, Anna Levin and Jane Wisbey
Designer: Bobby Birchall, Bobby&Co Design
Image grading: Stephen Johnson www.copyrightimage.com
Colour reproduction: Saxon Digital Services UK
Printing: Gorenjski tisk storitve d.o.o., Slovenia

MIX
Paper from responsible sources
FSC
www.fsc.org FSC® C057358

Contents

Foreword

Welcome to the *Highlights Volume 3* book, a record of the winners and 25 selected photographs for the People's Choice vote, from one of the world's most respected and most visited annual awards, Wildlife Photographer of the Year.

It is a great honour to chair the expert jury, which this year winnowed down nearly 49,000 entries to the 100 that made the exhibition. These are showcased at the Natural History Museum in London and in many other locations around the world. This exhibition combines outstanding photographs with the stories behind the images, of both the behaviour and how the pictures were taken. But it falls to me now to ask what we have achieved with our selection. What can it *do*?

It would be easy to say that this year's choice of overall winning image is a call to action. It may be seen as a statement from the jury that we must all – at least all who care about wildlife and the safekeeping of the planet – band together and work harder to stop the destruction of the natural world. Given the savagery and statistics behind Brent Stirton's story of rhinoceros poaching, it might be thought that we must do this with the greatest urgency and with every force we can muster. Beyond the images, worldwide data indicate we are at crisis point, with the collapse of environments and species. The awful image of one slaughtered and dehorned rhino might be a symbol of the devastation that is taking place in so many places, with so many creatures destroyed, with fragile ecosystems smashed and the fabric of our existence, too, under clear threat from man-made damage.

The overall winning image and its story sit in the company of other tough messages in this year's selection, succeeding other grisly images in years past. And even behind some of the quieter and more apparently appealing images, the facts of species collapse or habitat loss continue to pile up.

However, as chair of the Wildlife Photographer of the Year jury, I have to say that such a strong statement is not the primary purpose of the jury's work. You can take the position I've just outlined, or you can take an alternative view. In choosing the 100 images, our responsibilities were a little different.

Our task begins and ends with the photography. This makes the work both simpler and more difficult than a call to action around the issues raised by the images. We select according to categories, through which we endeavour to represent a range of subjects that reflect the natural world. Within this structure, we look for the 'best' photography, not the most pressing or newsworthy story. When seeking to identify the elusive 'best', we look for original imagery that is done with artistic and technical excellence. We cannot be led by pictures that might make headlines or iconic species that sell books. We are given the mysterious and truly demanding task, one made for long argument, of finding the images that take wildlife photography forward. They need to be pictures that combine great art and craft with relevance and topicality.

It's a mission impossible to get everything right for everybody, with every image. In the movies, Tom Cruise and his *Mission Impossible* chums have it easier, at least in the sense that most of their critics are, by the end, removed from being able to comment. For us, every year tends to mean there are more viewers, and more photographers, with opinions on the selection. If it inspires more debate and a quest for higher standards, then I am pleased.

We do not seek images that are overtly artful, though. The artistry in these pages is a by-product. It comes from the persistence and talent of photographers with a mission to capture amazing moments in the natural world, moments in the life of species and places that have never before been seen quite like this. The artistry is their vision and skill at the service of the content. The result is a book of wonders... and sometimes horror. And what that can do, to answer my previous question, is up to you. You may pick up a camera. You may travel. You may have fresh dreams, hopes – and fears – to attend to. You may have a mission.

Lewis Blackwell, chair of the jury, 2017

The Competition

To be placed in this competition is to be judged as being among the best of the best – an achievement that wildlife photographers worldwide aspire to. In fact, over the competition's more-than-50-year history, most of the world's leading wildlife photographers have at one time or another been awarded in it, and exposure as a Wildlife Photographer of the Year winner has been the incentive for many a young photographer to turn a passion into a career.

Though there are substantial cash awards, the rewards go beyond the financial. Each year's collection travels the world as a major exhibition and is publicized through a huge range of media.

The result is that it is seen by an audience of more than 50 million. So not only are photographic skill and aesthetic prowess showcased, but a picture with a powerful message will get maximum exposure.

Any photographer, whether professional or not, can submit pictures to this annual competition. The 14 categories exist to give full range to both the many subjects encompassed by natural history and the various styles of photography. There are also three age categories for young photographers, whose pictures are given prominence equal to those of the adult winners. This year, entries numbered nearly 49,000 from more than 90 countries, and 30 nationalities are represented in the final 100 photographs.

With such a large entry, judging has to take place over a number of weeks. It is conducted by an international jury, and at this stage, neither the entrants' names nor the full backstories to the pictures are known. (The stories you read in this book are gathered after the winners have been chosen.) What the judges look for are artistry and new ways of seeing nature – pictures that are arresting, thought-provoking or just beautiful in their simplicity and which remain memorable however many times they are viewed. But unlike most other competitions, great emphasis is placed on subjects being wild and free and on truth to nature, which extends to the strict rules on digital manipulation and processing adjustments.

What the winners tend to share in common is a love of nature that goes beyond personal photographic goals. Indeed, the award ceremony at London's Natural History Museum becomes a gathering of an international community of people who care deeply about the conservation and welfare of wildlife and the importance of the natural world.

The next competition opens on 23 October and closes on 14 December 2017. For the categories and rules, see www.wildlifephotographeroftheyear.com

Judges

Daniel Beltrá (Spain/USA), photographer

Jasper Doest (The Netherlands), wildlife photographer

Britta Jaschinski (Germany), wildlife photojournalist

Rosamund 'Roz' Kidman Cox (UK), writer and editor

Mattias Klum (Sweden), photographer and film-maker

CHAIR

Lewis Blackwell (UK), author and creative director

The Wildlife Photographer of the Year 2017

The Wildlife Photographer of the Year 2017 is **Brent Stirton**, whose picture has been chosen as the most striking and memorable of all the entries in the competition.

Memorial to a species

Brent Stirton

SOUTH AFRICA

A black rhino bull lies dead in South Africa's Hluhluwe Imfolozi Park, shot less than eight hours earlier. Its killers ambushed it at a waterhole, shooting the bull with a hunting rifle fitted with a silencer, and then hacked off its horns. An autopsy revealed that the bullet went through the rhino, causing massive tissue damage, but didn't kill it. The bull ran a short distance, fell to its knees and was then shot in the head from close range. It's a picture symbolic of the decimation of rhino populations throughout Africa, taken as part of an often-undercover investigation into the recent dramatic increase in the illegal trade in rhino horn. Black rhinos were once the most numerous of the world's rhino species. Today, they are critically endangered, with possibly as few as 4,000 remaining in the wild.

Canon EOS-1DX + 28mm f2.8 lens; 1/250 sec at f9; ISO 200; flash.

Brent Stirton

A senior correspondent for Verbatim and Getty Images, Brent Stirton shoots mainly for *National Geographic* magazine. He also works regularly for Human Rights Watch, *The New York Times Magazine*, *Le Figaro* and *GEO* magazine, and is a long-time photographer for WWF. He chooses to tell stories about 'issues that matter', focusing on wildlife and conservation, global health, diminishing cultures and sustainability. He has won this competition's photojournalism award four times, along with many other international awards, including nine from the World Press Photo Foundation and 10 Pictures of the Year Awards for his long-term investigative projects.

Murdered in the name of superstition and greed. Ruthless and brutal – Brent Stirton tells us how it is. Almost sculptural, he has captured the complete breakdown of an entire species. We are part of this crime scene, as this is the evidence that we allow the mass slaughter of our fellow Earth inhabitants. A powerful, iconic photo that makes me feel ashamed to be human.

Britta Jaschinski

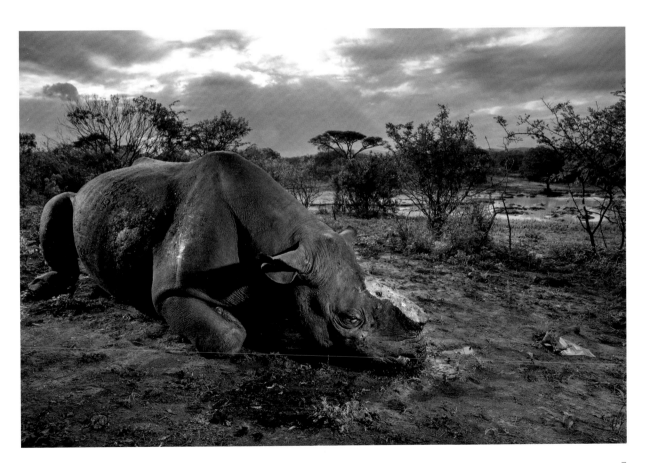

The Wildlife Photographer Portfolio Award

This award is given to one photographer whose outstanding collection of images focus on a specific subject or photographic approach. This year, Thomas Peschak highlights the remarkable diversity of the Seychelles and raises awareness of critical conservation issues.

Realm of the Seychelles

Thomas P Peschak

GERMANY/SOUTH AFRICA

Bohar snappers are among Aldabra's top predators – with the teeth to prove it. As the tide races into the huge lagoon of this Seychelles atoll, they crowd together in the channels that link it with the ocean, eager to catch the influx of smaller fish and invertebrates. Thomas's attempts to swim against the current were futile, and drifting with it gave him just a few minutes with the snappers. Luckily, he was working with scientists, who used baited underwater video cameras to survey sharks. Long before any sharks turned up, the inquisitive snappers went to investigate. 'I wrapped one leg around the steel cable anchoring a survey camera,' explains Thomas. He then used one hand to take pictures, while the other repelled snappers fascinated by his shiny underwater camera housing. Such is their boldness that these fish are easily caught by hook and line, and elsewhere in the western Indian Ocean, the species has been greatly depleted. It took hundreds of frames to get such a compelling split-level shot, capturing the dynamic water line with light bouncing off the surface and the arc of white clouds above, while balancing the colourful fish underneath.

Nikon D2X + 10.5mm f2.8 lens; 1/160 sec at f18; ISO 200; Subal housing; two Inon strobes.

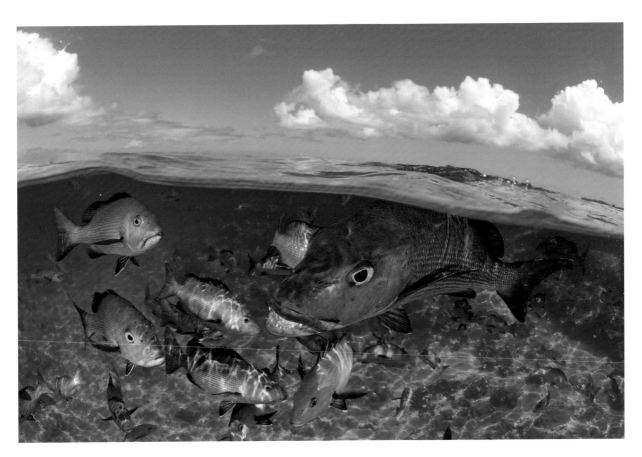

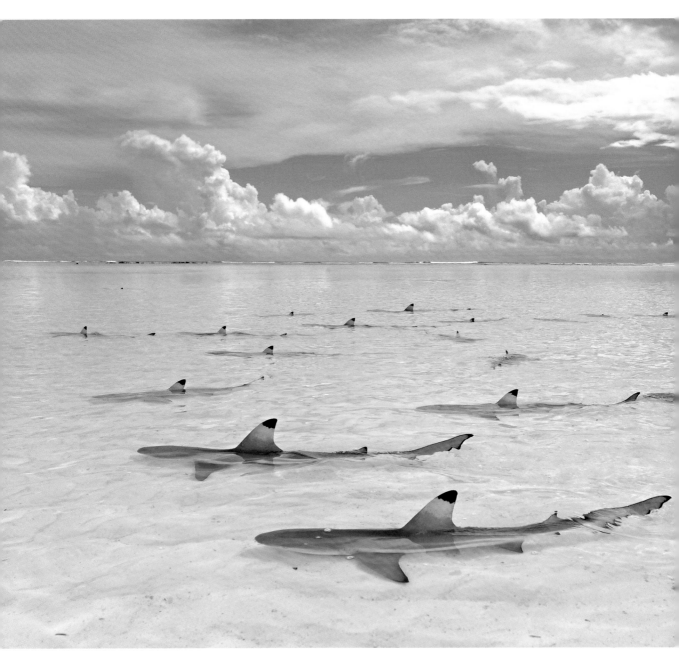

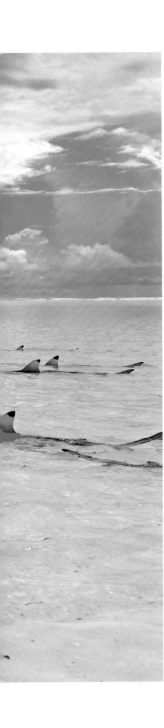

Before the tide turned

Picture a time before overfishing, development and pollution, and you may well find yourself here. Aldabra atoll in the Seychelles is extremely remote, protected and teeming with life. The lagoon – 30 kilometres (19 miles) long and 10 kilometres (6 miles) wide – is fringed with raised coral on what was once the rim of a volcano. Lounging in its ankle-deep water, an abundance of blacktip reef sharks wait for the tide to come in. With bellies touching the sand, black-tipped fins in the air, they point their snouts into the current to keep oxygenated water flowing over their gills. These powerful swimmers specialize in hunting small fish and invertebrates in very shallow waters over coral reefs. They are viviparous – the embryos develop inside the mother for about 11 months, and she gives birth to up to four pups. To get a higher perspective that included as many sharks as possible and waves breaking on the horizon, Thomas stood on a ladder in the shallows – for many hours, day after day – until the sharks lined up perfectly, with distant storm clouds adding a final touch to conjure the primordial scene.

Nikon D3S + 17–35mm f2.8 lens + graduated filters; 1/200 sec at f10; ISO 500.

Tree of life

To avoid hyperthermia – effectively cooking to death in their shells – Aldabra giant tortoises have to seek out shade before the midday temperatures peak at 43°C (109°F). Competition is fierce for a place under one of the few stunted trees on this inhospitable Seychelles atoll – there are not many other options when your thick shell stretches more than a metre (3 feet) long, though some hide in caves (the only tortoises known to do this). Giant tortoises – heavily exploited for food by sailors on passing ships – were driven to the brink of extinction in the Indian Ocean by the mid-1800s. A few persisted only on this remote atoll, and appeals for their protection (including by Charles Darwin in 1874) have led to the current population of about 100,000. Thomas used a low wide-angle to capture the restless siesta. 'There was constant jostling and shell-pushing to secure the coolest spots,' he says.

Nikon D3S + 17–35mm f2.8 lens + graduated filters; 1/250 sec at f6.3; **ISO 500; flash**.

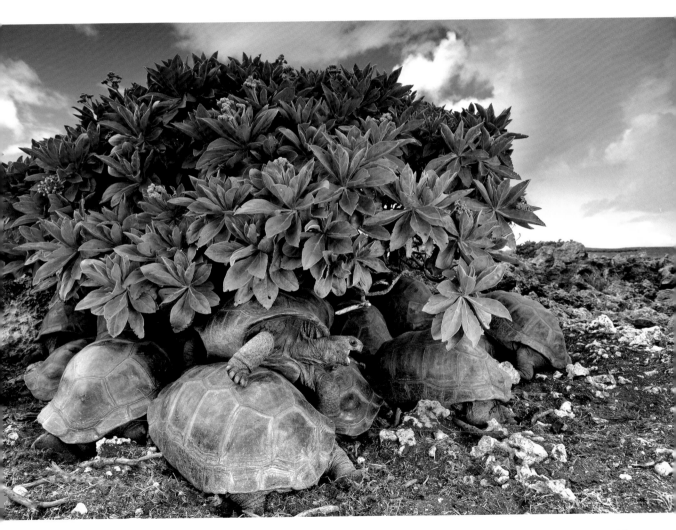

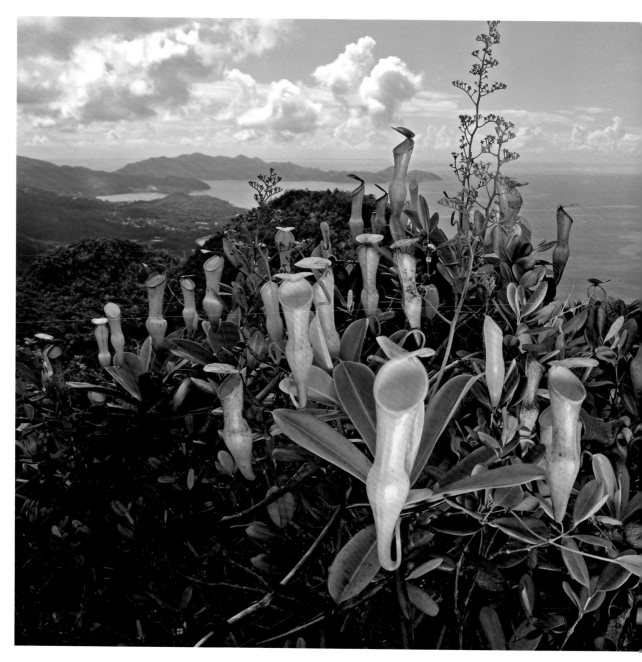

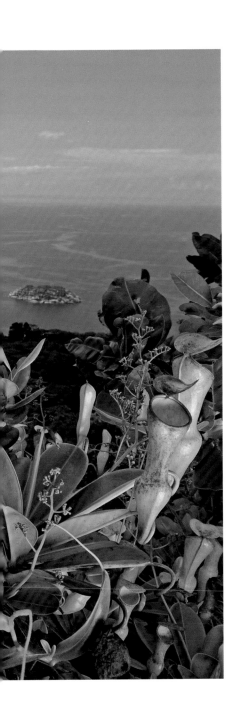

Goblets of desire

A carnivorous diet can make perfect sense for a plant growing on nutrient-poor soil, as this pitcher plant is. It's a species that is found only on the summits of two granite islands in the Seychelles, Mahé and Silhouette, and feeds on insects that get trapped in its liquid-filled carafes. This clump was at the edge of a cliff, entwined in the crown of a bois rouge tree – another plant found only in the Seychelles. 'I had to lean a ladder against my assistant,' says Thomas, 'who was all that stood between me and a tumble down the mountainside.' The midrib of each leathery leaf extends into either a tendril or a pitcher up to 21 centimetres (8 inches) long. Insects lured by the pitcher's sweet smell, colourful lid and nectar-containing rim, lose their grip on its waxy inner wall and slide helplessly into the acidic fluid below, to be digested by enzymes. Not all dinner guests succumb – a mosquito has evolved to lay its eggs only in these pitchers, which may also harbour hundreds of microscopic mites.

Nikon D3S + 24–70mm f2.8 lens at 24mm; 1/200 sec at f14; ISO 200; SB-800 flash.

Green haven

Aldabra is a haven for one of the most important populations of endangered green turtles in the Indian Ocean. Every high tide, the expansive seagrass beds in the atoll's lagoon attract a multitude of these grazing reptiles. Unlike other sea turtles, the adults are almost exclusively herbivorous. They can reach 1.5 metres (5 feet) long and take up to 40 years to become reproductively mature – longer than any other sea turtles. They migrate vast distances to return to the same nesting beaches every few years. Widely overexploited for their meat and eggs, green turtles (named after the colour of their fat) are now protected by a raft of international legislation. This has reduced direct harvesting, but other threats include fisheries bycatch, degradation of nesting and foraging sites and disease. Thomas waited weeks for a still evening with high tide around sunset to capture the turtle's iconic shape through the glassy water.

Nikon D3 + 14–24mm f2.8 lens at 14mm; 1/250 sec at f7.1; ISO 400; Nikon SB-800 flash.

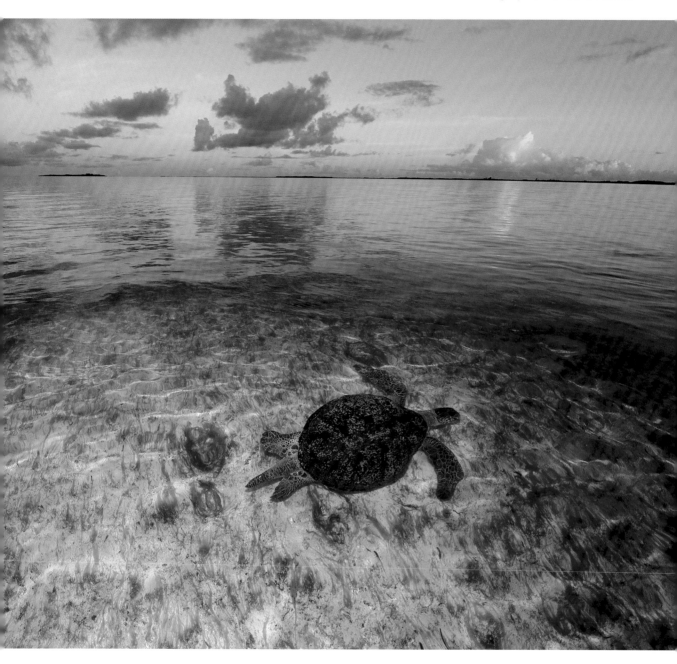

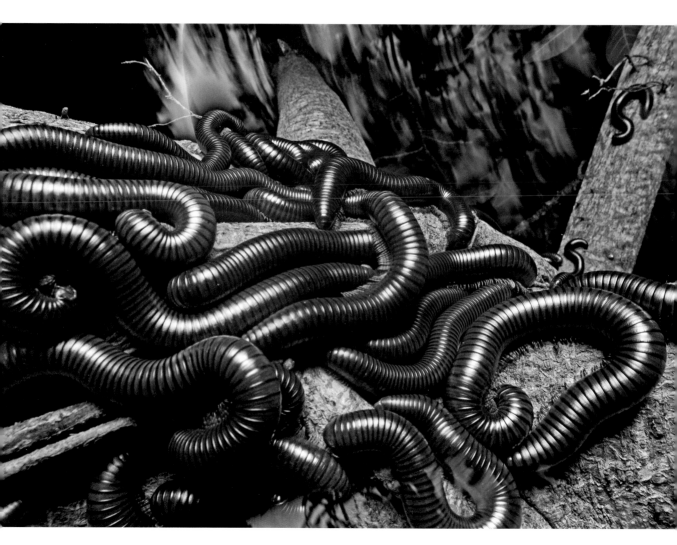

The night shift

In the heat of the day, they cluster in the crooks of branches, among tree roots and in the leaf-litter or crevices, but at dusk they come alive. Endangered Seychelles giant millipedes are the cleaners-in-chief of the forest floor, consuming decaying leaves in bulk. These finger-thick, 15-centimetre (6-inch) long invertebrates occur on only 14 small islands in the Seychelles. When brown rats reached Frégate in the mid-1990s, it was feared that the millipedes would be driven to extinction as the hungry rat population expanded. An international response restored the island to a rodent-free sanctuary and established a back-up millipede population in captivity. But now climate change resulting in longer dry seasons is favouring a parasitic fly that kills adult millipedes. And on other islands, invasive plant species such as cinnamon are damaging their habitat – the millipedes prefer eating native leaf-litter, perhaps because it contains more moisture. So far numbers are holding up, but the threats persist for these glossy stars of forest recycling.

Nikon D3S + 20mm f2.8 lens; 1/5 sec at f20; ISO 2000; SB-800 flash.

Portraits

Revealing the personality of the subjects or adding an emotional element to an image, these memorable photographs draw on the aesthetic of the natural world to entice us in.

Contemplation

Peter Delaney

IRELAND/SOUTH AFRICA

Totti couldn't have tried harder. For more than an hour, he posed, gestured and called to entice one particular female down from the canopy, but nothing worked. The object of his desire ignored him. Peter, too, was frustrated. He had spent a long, difficult morning tracking the chimpanzees – part of a troop of some 250 – through Uganda's Kibale National Park. It was humid, the ground was wet and the dense undergrowth meant that, whenever he did catch up with the chimpanzees, all he got was tantalizing glimpses as they swung from tree to tree. 'Photographing in a rainforest with dim light and splashes of sunlight means your exposure settings are forever changing. Keeping my camera at its optimum ISO setting meant low shutter speeds, and as the park authorities don't allow tripods and monopods, getting a sharp image with a hand-held camera was a challenge,' he says. Totti was on the ground at least, but he was busy with vigorous courtship, pacing and gesticulating. It was only when he finally flopped down, worn out with unrequited love, that Peter had his chance. 'He lay back, hands behind his head, and rested for a moment, as if dreaming of what could have been.'

Fujifilm X-T1 + 50–140mm lens at 140mm; 1/75 sec at f2.8 (–1.3 e/v); ISO 3200.

Beautiful, emotional and simplistic. This image proves that less is more.
Mattias Klum

A ray of light dramatically highlights this candid portrait, which seems to capture a contemplative creature with whom we can relate – apes share 99 per cent of our genes.
Daniel Beltrá

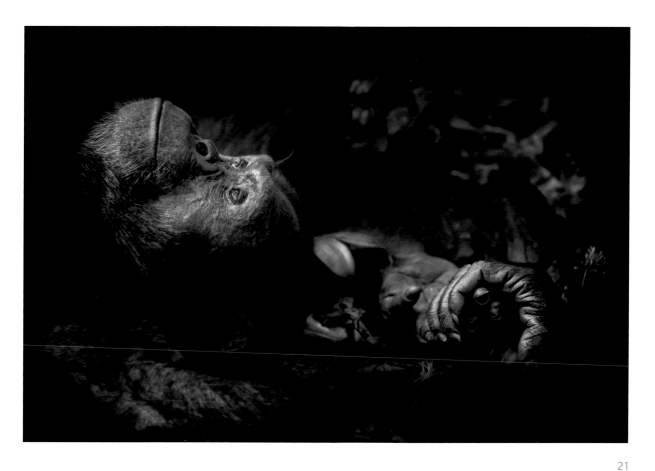

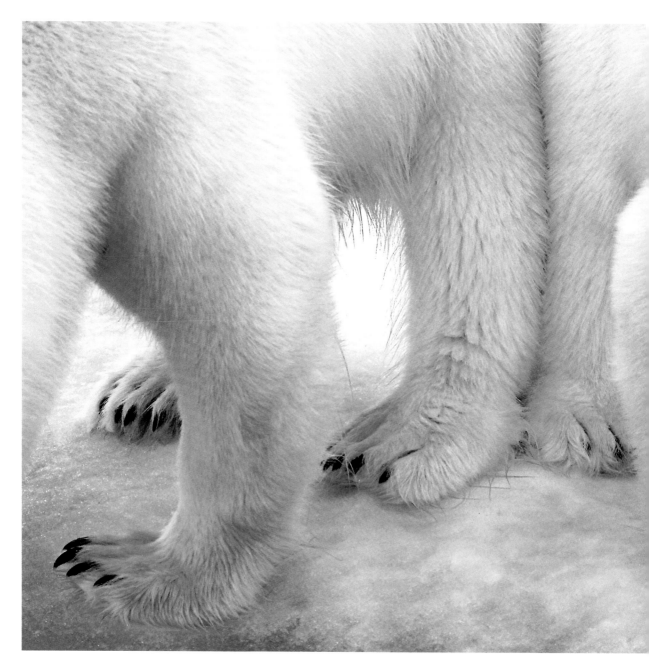

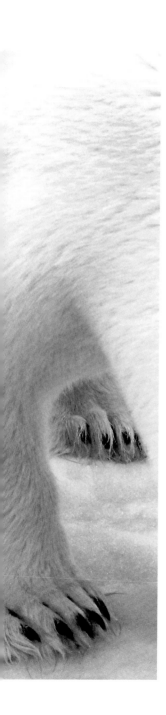

An original and very different portrayal of polar bears, this unique and balanced composition leaves tantalizing details to the imagination.
Daniel Beltrá

The subject is unmistakably polar bears, but the creation is an imaginative, sensitive evocation of a mother and cub – highlighting the perfection of fur against ice, the symmetry of legs and the pattern of claws within their furry pads. This is a proper use of the black-and-white medium and an image deserving of its award.
Roz Kidman Cox

Polar pas de deux
Eilo Elvinger
LUXEMBOURG

From her ship, anchored in the icy waters off Svalbard, in Arctic Norway, Eilo spotted a polar bear and her two-year-old cub in the distance, slowly drawing closer. Polar bears are known as hunters, mainly of seals – they can smell prey from nearly a kilometre (more than half a mile) away – but they are also opportunists. Nearing the ship, they were diverted to a patch of snow soaked in leakage from the vessel's kitchen and began to lick it. 'I was ashamed of our contribution to the immaculate landscape', says Eilo, 'and of how this influenced the bears' behaviour.' Mirroring each other, with back legs pressed together (cub on the right), they tasted the stained snow in synchrony. Such broad paws make fine swimming paddles and help the bears to tread on thin ice, and their impressive non-retractable claws – more than 5 centimetres (2 inches) long – act like ice picks for a better grip. Mindful of the species' shrinking habitat – climate change is reducing the Arctic sea ice on which the bears depend – Eilo framed her shot tightly, choosing black and white to 'reflect the pollution as a shadow cast on the pristine environment'.

Canon EOS-1DX + 200–400mm f4 lens at 200mm; 1/640 sec at f9 (+0.7 e/v); ISO 6400.

Diversity

The astounding breadth of life on Earth is instantly recognisable in this section. The images evoke atmosphere and a sense of place, as well as revealing memorable behaviours that add to our understanding of the natural world.

The ancient ritual

Brian Skerry

USA

Like generations before her, the leatherback turtle shifts her considerable weight with her outsized, strong front flippers and moves steadily back to the ocean. Leatherbacks are the largest, deepest-diving and widest-ranging sea turtles, the only survivors of an evolutionary lineage that diverged from other sea turtles 100–150 million years ago. Much of their lives are spent at sea, shrouded in mystery. When mature, their leathery shells now averaging 1.6 metres (5 feet 3 inches) long, females return to the shores where they themselves hatched to lay their own eggs. Sandy Point National Wildlife Refuge on St Croix, in the US Virgin Islands, provides critical nesting habitat, successfully managed for decades. Elsewhere, leatherbacks are not so lucky, threatened primarily by fisheries bycatch as well as factors including human consumption, coastal development and climate change. The females each lay about 100 eggs in nests dug deep in the sand. Some 60 days later, the hatchlings emerge, their sex influenced by incubation temperatures (hotter nests produce more females). Nesting turtles are not seen every night at Sandy Point, and were often too far away for Brian to reach. When after two weeks he got the encounter he wanted – under clear skies, with no distant city lights – he hand-held a long exposure under the full moon, artfully evoking a primordial atmosphere in this timeless scene.

Nikon D5 + 17–35mm f2.8 lens at 24mm; 10 sec at f8; ISO 1600; Nikon flash at 1/64th power + tungsten gel; Nikon remote release.

For me there is much drama in this photo. I love the colours and the light, but the movement and the shadows create an eerie atmosphere and I cannot help thinking how vulnerable this species is.

Britta Jaschinski

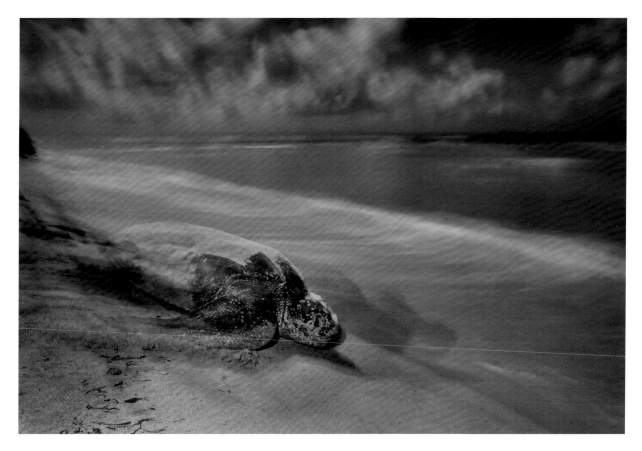

The best behaviour shots are the ones that catch the moment, placing you in the action. This is one of them. Of course, it's planned – both in the angle and the lighting – with the reward being an action shot that documents what a brush turkey is famous for, building an incubation pile.

Roz Kidman Cox

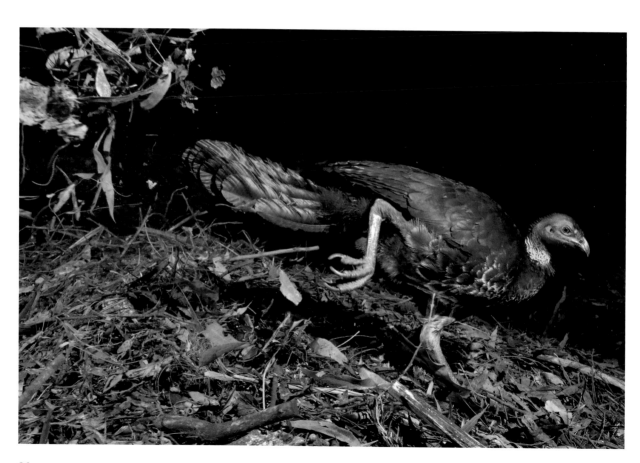

The incubator bird

Gerry Pearce

UK/AUSTRALIA

Most birds incubate their eggs with their bodies. Not so the Australian brush turkey, one of a handful of birds – the megapodes – that do it with an oven. Only the males oversee incubation. In this case, a male had chosen to create his nest-mound near Gerry's home in Sydney, bordering Garigal National Park. It took a month to build, out of leaves, soil and other debris, at which point it was more than a metre high – mounds used year after year can be more than 4 metres (13 feet) wide and 2 metres (6 feet 7 inches) high. The brush turkey then invited a succession of females to mate with him. If he and his mound were to their liking, they would lay a clutch of eggs in the mound. Always there was a chance that the eggs had been fertilized by a male she had visited previously, and that in a kind of nest-relay, some of his own babies would hatch in another male's mound. As the organic matter in the mound decayed, heat was generated, and to check that the incubation temperature was the necessary 33°C (92°F), the brush turkey regularly stuck his head in and, using heat sensors in his upper bill, checked a mouthful. In this picture, he is piling on more insulation to raise the temperature. If it gets too hot, he will rake it off. Gerry spent four months watching the male and his mound, every day from dawn. After seven weeks, and despite egg raids by a large lace monitor (lizard), at least a quarter of the 20 or so eggs hatched. The big chicks were strong enough to kick (not peck) their way out of their shells and up through the compost heap. Fully independent, they left home straight away to start life on their own in the bush.

Canon 7D Mark II + 18–200mm f3.5 lens; 1/1000 sec at f9; ISO 1600; two Yongnuo Speedlite flashes + wireless trigger.

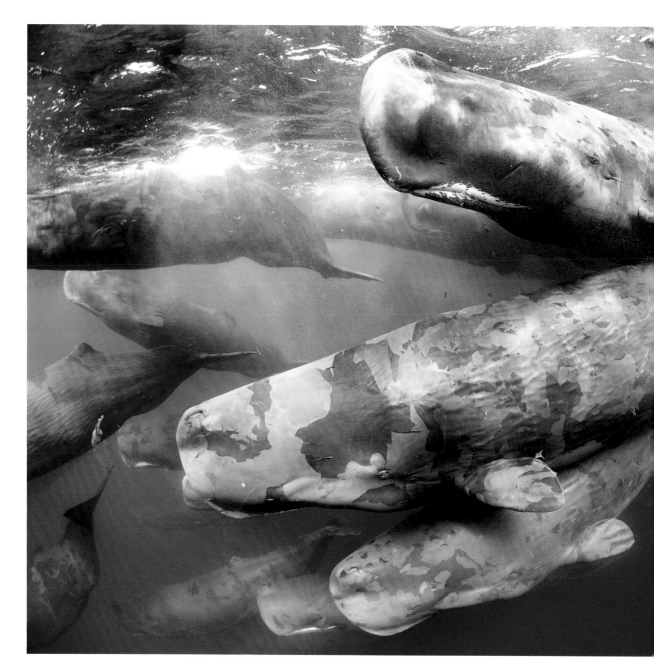

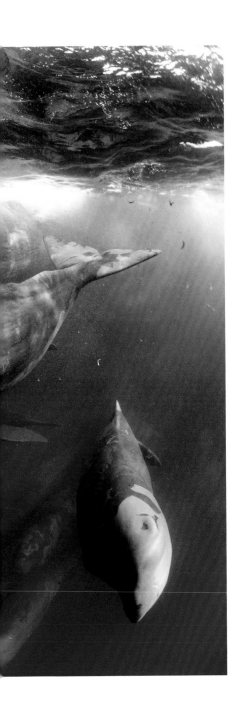

This picture has power, action and drama – and makes you wonder about both the behaviour and the fact that the photographer is in amongst such a gathering of giants. You can almost feel the sonic vibrations and the water pressure as the sperm whales sweep by.

Roz Kidman Cox

Giant gathering

Tony Wu
USA

Dozens of sperm whales mingled noisily off Sri Lanka's northeast coast, stacked as far down as Tony could see. This was part of something special – a congregation of dozens, perhaps hundreds, of social units, like a kind of gathering of the clans. Sperm whales are intelligent, long-lived and gregarious, and groups play, forage, interact and communicate in different ways and have distinctive cultures. Aggregations like this could be a critical part of their rich, social lives but are rarely reported. Some two thirds of the sperm whale population was wiped out during the peak of industrialized whaling in the twentieth century. But commercial whaling was banned in 1986, and this kind of major gathering could be 'a sign that populations are recovering', says Tony, who has spent 17 years studying and photographing sperm whales. Tactile contact is an important part of sperm whale social life, but rubbing against each other also helps slough off dead skin. So the water was filled with a blizzard of skin flakes. More photographically challenging was the smearing of the camera-housing dome with oily secretions from the whales and thick clouds of dung released as they emerged from the gigantic cluster. But through continually swimming to reposition himself and the tolerance of the whales themselves, Tony got a unique photograph of the mysterious Indian Ocean gathering.

Canon EOS 5D Mark III + 15mm f2.8 lens; 1/250 sec at f6.3; ISO 800; Zillion housing + Pro-One optical dome port.

With wildlife, especially when under water, you can't plan for the unexpected, but if you have the knowledge, the instinct and the camera-readiness to react, you'll get the shot – and this unique image is the proof.

Roz Kidman Cox

Crab surprise

Justin Gilligan

AUSTRALIA

Out of the blue, an aggregation of giant spider crabs the size of a football field wandered past. Known to converge in their thousands elsewhere in Australian waters – probably seeking safety in numbers before moulting – such gatherings were unknown in Mercury Passage off the east coast of Tasmania. Justin was busy documenting a University of Tasmania kelp transplant experiment and was taken completely by surprise. A single giant spider crab can be hard to spot – algae and sponges often attach to its shell, providing excellent camouflage – but there was no missing this mass march-past, scavenging whatever food lay in their path on the sandy sea floor. 'About 15 minutes later, I noticed an odd shape in the distance, moving among the writhing crabs,' says Justin. It was a Maori octopus that seemed equally delighted with the unexpected bounty. Though large – the biggest octopus in the southern hemisphere, with muscular arms spanning up to 3 metres (10 feet) and knobbly, white-spotted skin – it was having trouble choosing and catching a crab. Luckily for Justin, the stage was set with clear water and sunlight reflecting off the sand. He quickly adjusted his camera and framed the octopus finally making its catch.

Nikon D810 + 15mm f2.8 lens; 1/100 sec at f14; ISO 400; Nauticam housing; two Ikelite DS161 strobes.

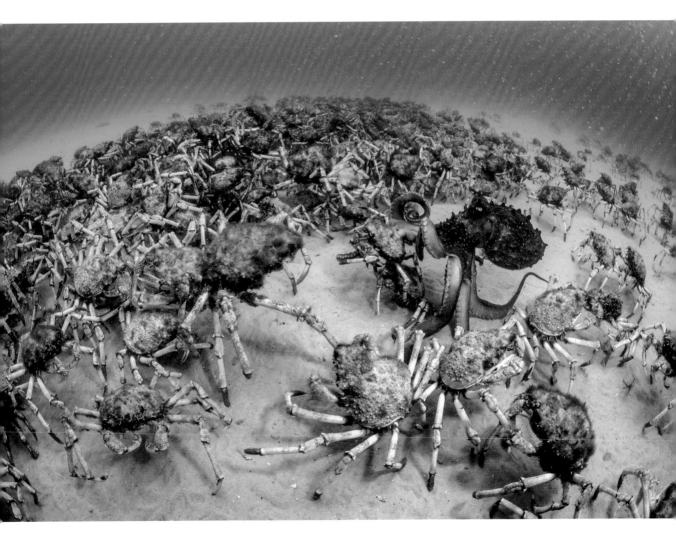

It took me a while to work out the scale of this landscape but when I did, it blew me away.

Britta Jaschinski

Plants are what make the rest of life on Earth possible, clothing the land and providing oxygen, food and shelter. Here is a picture that could be said to symbolise that, made memorable and mysterious by catching the perfect light.

Roz Kidman Cox

Tapestry of life

Dorin Bofan

ROMANIA

It was a quiet morning with flat light as Dorin stood alone on the shore of the fjord. He was contemplating the immense landscape bounding Hamnøy in the Lofoten Islands, Norway, when here and there, the clouds parted, allowing shafts of sunlight to fall on to the great walls of metamorphic rock, lighting up the swathes of vegetation coating the canyon and its slopes. The mountains here rise steeply from the sea – a sheer drop of 200 metres (660 feet) in some places – yet mountain birches manage to gain a foothold, some clinging to existence in the most precipitous spots. This mountain variety of downy birch is relatively small, and here in its autumn colours, is glowing gold. Dwarf willow species carpet much of the ground below. Drawn to the gentle curve at the base of the rock-face – like the 'moss-covered trunk of a veteran tree in a damp ancient wood' – Dorin composed his picture, waiting until a break in the clouds yielded this brief moment in a timeless landscape, cloaked in a tapestry of Arctic–alpine vegetation.

Canon EOS 650D + 70–200mm f4 lens at 100mm; 1/100 sec at f5.6 (-1 e/v); ISO 200; Manfrotto tripod.

The night raider

Marcio Cabral

BRAZIL

It was the start of the rainy season, but though the night was
humid, there were no clouds, and under the starry sky, the
termite mounds now twinkled with intense green lights. For
three seasons, Marcio had camped out in Brazil's cerrado region,
on the vast treeless savannah of Emas National Park, waiting
for the right conditions to capture the light display. It happens
when winged termites take to the sky to mate. Click beetle larvae
living in the outer layers of the termite mounds poke out and
flash their bioluminescent 'headlights' to lure in prey – the flying
termites. After days of rain, Marcio was finally able to capture the
phenomenon, but he also got a surprise bonus. Out of the darkness
ambled a giant anteater, oblivious of Marcio in his hide, and began
to attack the tall, concrete-mud mound with its powerful claws,
after the termites living deep inside. Protected from bites by its
long hair and rubbery skin, the anteater extracted the termites
with its exceptionally long, sticky tongue. It has limited vision but
a keen sense of smell to help locate insects. Luckily, the wind was
in Marcio's favour, and the anteater stayed long enough for him to
make his picture, using a wide-angle lens to include the landscape,
a low flash and a long exposure to capture both the stars and the
light show.

**Canon EOS 5DS R + Nikon 14–24mm f3.5 lens + Fotodiox adapter +
ND filter; 30 sec at f3.5; ISO 5000; two Metz 32 flashes + diffuser;
Manfrotto tripod.**

Environments

Earth, air, water, ice. It's the combination of different environments that makes our planet so special. The images in this section emphasize two conflicting ideas: human insignificance and human impact.

The jellyfish jockey

Anthony Berberian

FRANCE

In open ocean far off Tahiti, French Polynesia, Anthony regularly dives at night in water more than 2 kilometres (1¼ miles) deep. His aim is to photograph deep-sea creatures – tiny ones, that migrate to the surface under cover of darkness to feed on plankton. This lobster larva (on top), just 1.2 centimetres (half an inch) across, with spiny legs, a flattened, transparent body and eyes on stalks, was at a stage when its form is called a phyllosoma. Its spindly legs were gripping the dome of a small mauve stinger jellyfish. The pair were drifting in the current, the phyllosoma saving energy and possibly gaining protection from predators deterred by the jelly's stings, its own hard shell probably protecting it from stings. The phyllosoma also seemed able to steer the jelly, turning it around at speed as it moved away from Anthony. The odd thing about the jelly was that it had few tentacles left, suggesting that the little hitchhiker was using it as a convenient source of snacks. In fact, a phyllosoma has a special digestion to deal with jellyfish stinging cells, coating them with a membrane that stops the stings penetrating its gut. In several hundred night dives, Anthony met only a few lobster larvae, and it took many shots of the jellyfish jockey to get a composition he was happy with – a portrait of a creature rarely observed alive in its natural surroundings.

Nikon D810 + 60mm f2.8 lens; 1/250 sec at f22 (–0.3 e/v); ISO 64; Nauticam housing + Nauticam SMC-1 super-macro converter; Inon Z-240 strobes.

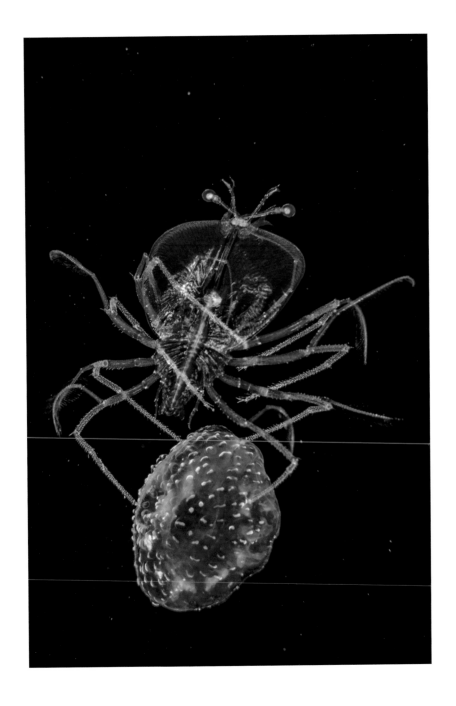

The ice monster

Laurent Ballesta

FRANCE

Laurent and his expedition team had been silenced by the
magnitude of the ice blocks – mountainous pieces of the ice
shelf – awed in the knowledge that only 10 per cent of their
volume is ever visible above the surface. The dive team were
working out of the French Dumont d'Urville scientific base in east
Antarctica, recording with film and photography the impact of
global warming. Ice shelves in some parts of the East Antarctic Ice
Sheet are melting faster than scientists had previously assumed,
threatening a movement of land ice into the sea and raising sea
levels dramatically. When Laurent spotted this relatively small
iceberg, he saw the chance to realize a long-held ambition – to
show for the first time the underwater part. The berg was stuck
in the ice field – hovering like a frozen planet – unable to flip
over and so safe to explore. But it took three days, in virtually
freezing water, to check out the location, install a grid of lines
from the seabed to buoys (so that Laurent could maintain a
definite distance from it) and then take the series of pictures – a
substantial number, with a very wide-angle lens – to capture the
entire scene. 'None of us could see the whole thing under water.
Close-to, it was overflowing from our view. From a distance, it
disappeared into the fog.' So, back at the station, it was a tense
wait at the computer, while the result of 147 stitched images
came together on screen. The front of the vast foot of the frozen
monster, polished by the current probably over years, shone
turquoise and blue in the light penetrating the ice ceiling, dwarfing
Laurent's companions as they lit its sides.

**Nikon D4S + 13mm f2.8 lens; 1/30 to 1/60 sec at f6.3 – 147 stitched
images; ISO 3200; Seacam housing; flashlights.**

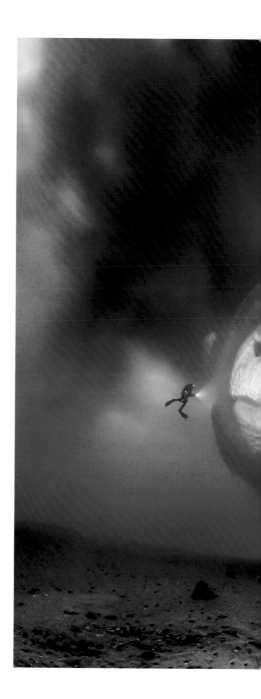

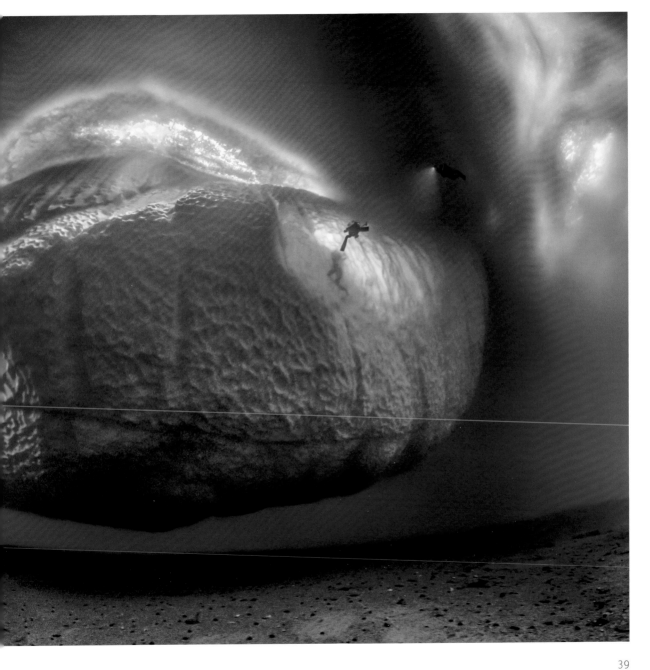

Documentary

This award showcases powerful stories of personal dedication to nature conservation and action, highlighting the terrible impacts we have on our planet – purposefully or unwittingly.

The Wildlife Photojournalist Award: Single Image – Palm-oil survivors

Aaron 'Bertie' Gekoski

UK/USA

In eastern Sabah, on the island of Borneo, three generations of Bornean elephants edge their way across the terraces of an oil-palm plantation being cleared for replanting. Palm oil is a lucrative global export, and in the Malaysian state of Sabah, where the majority of rainforest has already been logged (only 8 per cent of protected intact forest remains), the palm-oil industry is still a major driver of deforestation, squeezing elephants into smaller and smaller pockets of forest. Increasingly they wander into oil-palm plantations to feed, where they come into conflict with humans, with elephants being shot or poisoned. (In 2013, poison used in a plantation killed a herd of 14 elephants – the sole survivor, a calf, was found caressing its dead mother.) Reports of elephant attacks on humans are also on the rise. Today, the fragmented population of Bornean elephants – regarded as a subspecies of the Asian elephant that may have been isolated on the island of Borneo for more than 300,000 years – is estimated to number no more than 1,000–2,000. Elephants form strong social bonds, and females often stay together for their entire lives. Here, the group probably comprises a matriarch, two of her daughters and her grand-calf. With the light fading fast, Bertie acted quickly to frame an image that symbolizes the impact that our insatiable demand for palm oil (used in half of the products on supermarket shelves) has on wildlife. 'They huddled together, dwarfed by a desolate and desecrated landscape. A haunting image,' he says.

Nikon D700 + 80–200mm f2.8 lens at 120mm; 1/500 sec at f3.2; ISO 400.

This photograph of elephants walking through a clearcut forest strikingly highlights the conflict between human endeavours and the needs of the natural world. A huge and powerful animal as majestic as the elephant appears lost and out of place in this artificial, human-made landscape.

Daniel Beltrá

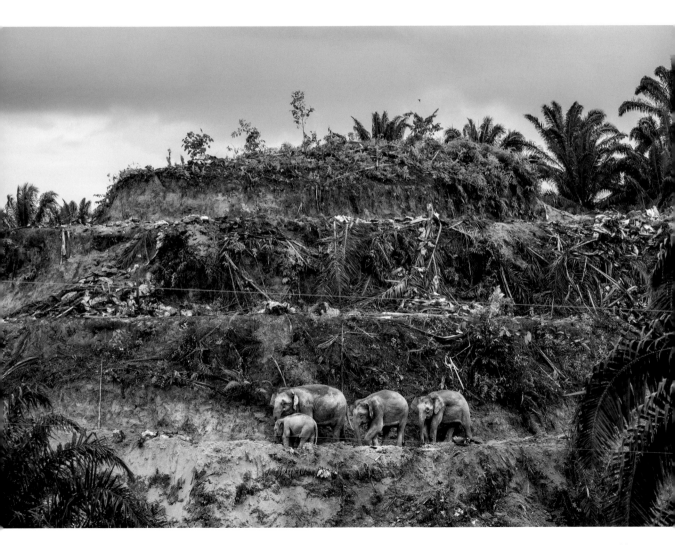

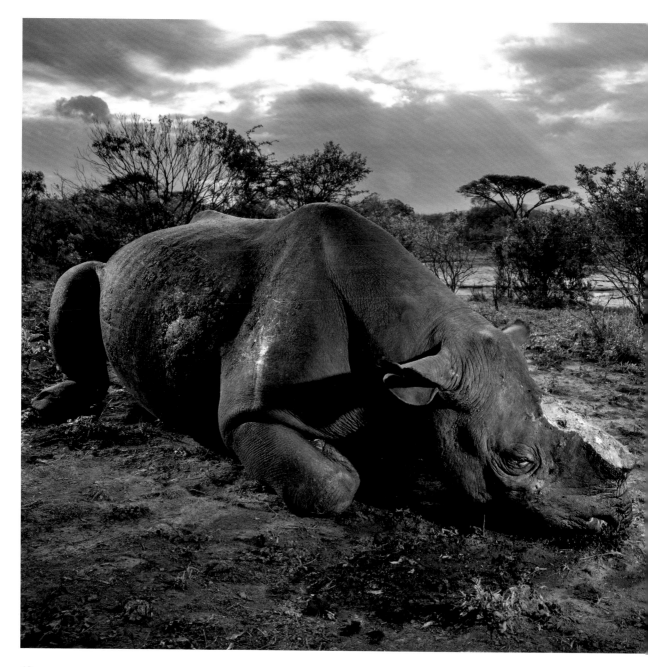

The Wildlife Photojournalist Award: Story – Rhino horn: the ongoing atrocity

Brent Stirton
SOUTH AFRICA

This is a follow-up to Brent Stirton's 2012 investigation of the illegal international trade in rhino horn. It's a trade fuelled by ever-increasing demand for horn in Asia – China and Vietnam principally – where there is a long-held belief that it has medicinal value. Four years later, he found trade involving criminal syndicates and horn with a street value higher than gold or cocaine. In Vietnam, rising wealth has coincided with a reinforced belief that rhino horn – the same material as toenails – can cure everything from cancer to kidney stones. All of the world's rhino species are targets for poaching, but since South Africa has about 80 per cent of the remaining rhinos, that is where most have been killed – more than 1,000 a year since 2013, with insider sources saying as many as 1,500. There is hope, if countries such as China could take the lead, but there are also powerful enemies in corruption, greed and, above all, ignorance.

Memorial to a species

The killers were probably from a local community but working to order. Entering the Hluhluwe Imfolozi Park at night, they shot the black rhino bull using a silencer. Working fast, they hacked off the two horns and escaped before being discovered by the reserve's patrol. The horns would have been sold to a middleman and smuggled out of South Africa, probably via Mozambique, to China or Vietnam. For the reserve, it was grim news, not least because this is where conservationists bred back from near extinction the subspecies that is now the pre-eminent target for poachers, the southern white rhino. For the photographer, the crime scene was one of more than 30 he visited in the course of covering this tragic story.

Canon EOS-1DX + 28mm f2.8 lens; 1/250 sec at f9; ISO 200; flash.

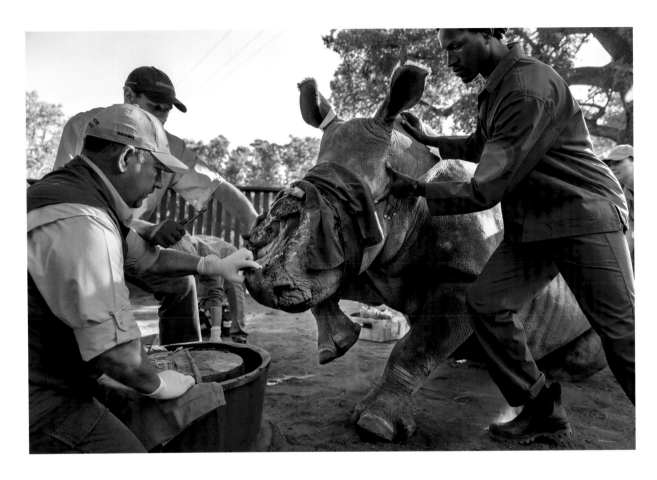

Saving Hope

Vets attend to a gaping wound on a female white rhino found hiding in the South African bush in April 2015. Poachers had darted her and cut off her horns, along with much of her face. Given the name Hope, she was brought to Saving the Survivors, a South African charity run by veterinary surgeons caring for endangered animals. Hope underwent 16 surgical procedures, and because the poachers had removed so much bone, a base for a protective shield had to be drilled onto her. As the enormous wound began to heal, the challenge was to keep it covered – each attempt was thwarted by a spirited, 2-tonne animal determined to scratch an itch. The team experimented with elastic shields made of skin and, eventually, a Canadian material developed for use in abdominal surgery. By September 2016, Hope was recovering well, but in November she died suddenly from an intestinal infection. Her devastated carers describe her legacy as increased expertise in treating brutal wounds and drawing worldwide attention to the plight of rhinos.

Canon EOS-1DX + 24mm lens; 1/200 sec at f3.2; ISO 200.

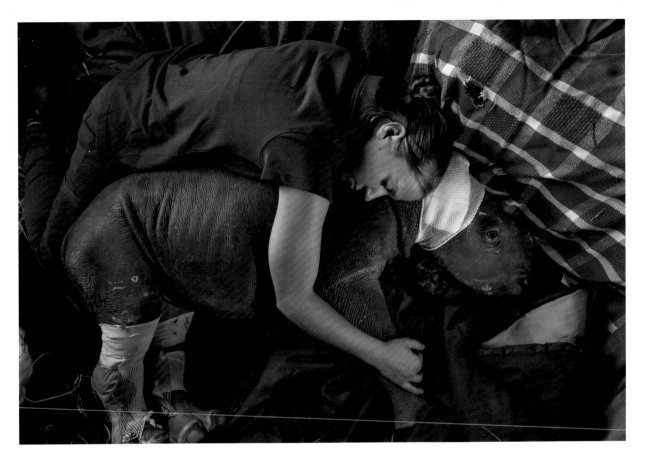

Caring for Lulah

Full-time caregiver Dorota Ladosz comforts Lulah, an orphaned black rhino, after an operation to clean a leg infection. Lulah was found by rangers after her mother had been killed by poachers in Kruger National Park, South Africa's largest wildlife reserve. Hyenas had attacked the one-month-old calf, chewing off her ears and parts of her nose and severely injuring a rear leg. The rangers brought her to the safety of Care for Wild Africa, a rhino orphanage run by a small team assisted by volunteers from around the world. Dorota was appointed to look after Lulah, keeping watch on her injuries, feeding her, taking her temperature and sleeping beside her. Care for Wild Africa has become the largest rhino sanctuary in the world – at the date of this photograph, caring for 27 rhino orphans. A rhino calf has a strong bond with its mother, and though weaned at 18 months, it will stay with her for up to three years. All the orphans had been present when their mothers were killed, and many were also attacked by the poachers.

Canon EOS-1DX + 28mm f2 lens; 1/125 sec at f2.8; ISO 3200; flash.

Last of a kind

Armed guards in Kenya's Ol Pejeta Conservancy keep a 24-hour watch over three northern white rhinos – the last of their kind. The guards all speak of their deep sense of vocation and the close relationship they have developed with their charges. Northern white rhinos, a subspecies of white rhino, though considered by some as a full species, once ranged over an area of central Africa, but years of poaching and civil wars decimated the populations until, by 2006, there were no signs of them in the wild. These three are the last captive animals, all from a zoo in the Czech Republic, including (here) 43-year-old Sudan, the last male. All hope that the climate of their native habitat would help them breed has evaporated, though scientists are exploring the possibility of using stem-cell technology to save their genes. But even if it proved possible to engineer offspring, they would be badly inbred, and if the desire for rhino horn remains, there is no guarantee they wouldn't go the way of their wild relatives.

Canon EOS 5D + 35mm f1.4 lens; 1/250 sec at f8; ISO 100.

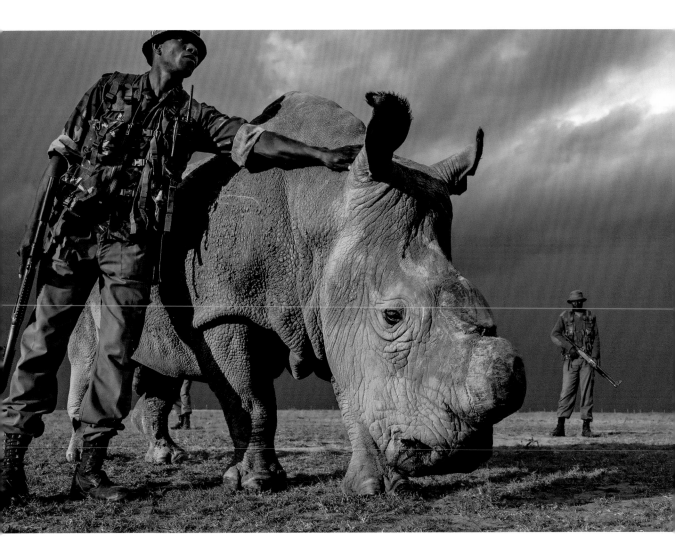

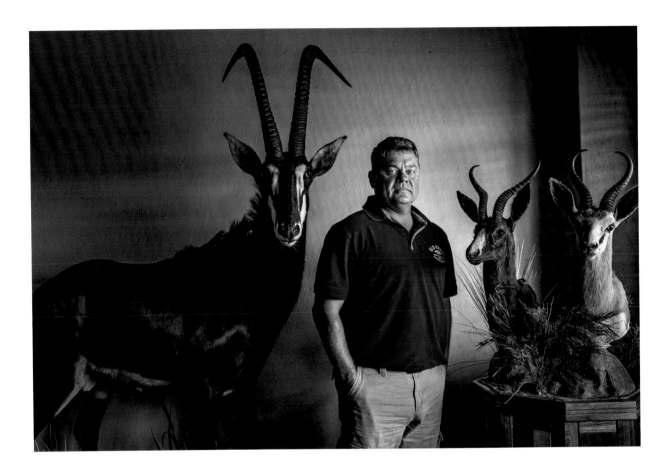

The rhino-horn farmer

South African Dawie Groenewald poses at his game farm in Limpopo province, where he breeds valuable wild animals for sale and hunting. He is the subject of a six-year-long court case involving charges relating to illegal rhino handling, horn theft and money laundering. Groenewald denies any wrongdoing. Together with John Hume, who farms more than 1,400 rhinos and has the world's largest stockpile of horn, he has been one of the driving forces behind efforts to legalize trade in rhino horn. They argue that farming rhino for their horns, which regrow, could depress prices and supply the demand without any animals having to be killed. Conservation organizations counter that a legal trade would stimulate demand and become a mechanism for even more poached horn to be traded. In April 2017, John Hume and Johan Kruger won a legal case to allow internal trade of horn in South Africa. Though the ban on international trade remains, conservationists fear that the internal trade will allow illegal horn to be passed off as legal.

Canon EOS-1DX + 35mm f1.4 lens; 1/250 sec at f2.8; ISO 800.

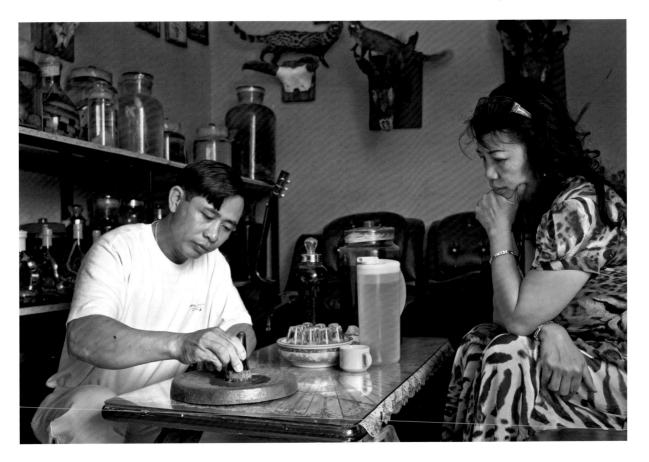

Point of sale

Rubbing rhino horn against a specially surfaced bowl, then mixing in water, a traditional-medicine specialist in Vietnam prepares a potion for his client. Horn is used for many ailments; this client has breast cancer. Cancer is not traditionally treated with rhino horn, but prominent Vietnamese vouching for its efficacy have fuelled a surge in demand, pushing prices ever higher. Its sale is illegal in Vietnam, just as exporting it is illegal in South Africa, but it is readily available. The main consumers are wealthy men who take it as a display of prestige and power, but many people keep a stock in case of illness. Brent went under cover in Vietnam to photograph this phenomenon. Some people understand that rhinos are threatened species, he says, but if they are desperately ill, that outweighs all other concerns. He concludes that the responsibility lies with the country's leaders to curtail this growing trend. Meanwhile, the dovetailing of ancient traditions with contemporary fashion drives another species to extinction.

Fuji FinePix X100 + 35mm f2 lens; 1/210 sec at f4; ISO 640.

Young Photographers

The Young Wildlife Photographer of the Year 2017 is Daniël Nelson – the winning photographer whose picture has been judged to be the most memorable of all the pictures by photographers aged 17 or under.

The good life

Daniël Nelson

THE NETHERLANDS

Daniël met Caco in the forest of Odzala National Park in the Republic of Congo. A three-hour trek through dense vegetation with skilled trackers led him to where the 16-strong Neptuno family was feeding and to a close encounter with one of the few habituated groups of western lowland gorillas. In the wet season they favour the plentiful supply of sweet fruit, and here Caco is feasting on a fleshy African breadfruit. Caco is about nine years old and preparing to leave his family. He is putting on muscle, becoming a little too bold and is often found at the fringe of the group. He will soon become a solitary silverback, perhaps teaming up with other males to explore and, with luck, starting his own family in eight to ten years' time. Western lowland gorillas are critically endangered, threatened by illegal hunting for bushmeat (facilitated by logging and mining roads), disease (notably the Ebola virus), habitat loss (to mines and oil-palm plantations) and the impact of climate change. In his compelling portrait of Caco – relaxed in his surroundings – Daniël captured the inextricable similarity between these wild apes and humans and the importance of the forest on which they depend.

Canon 6D + Sigma 50–500mm f4.5–6.3 lens at 500mm; 1/30 sec at f6.3; ISO 800.

Daniël Nelson

It was at age six, on a family trip to Zambia, that Daniël first held a camera and realized he could create his own pictures. Growing up in Amsterdam but being lucky enough to travel, he has retained his passion for wildlife photography and built up a portfolio of work. His award-winning image was taken when he was 16. Now that he's left school, he's off backpacking across Africa – a 'first milestone in my career as a photographer'.

It's the expression and the pose that make the shot, putting aside the fact that this is a wild lowland gorilla in a remote rainforest. The intimate moment has been framed as if glimpsed through a window. A special shot indeed.
Roz Kidman Cox

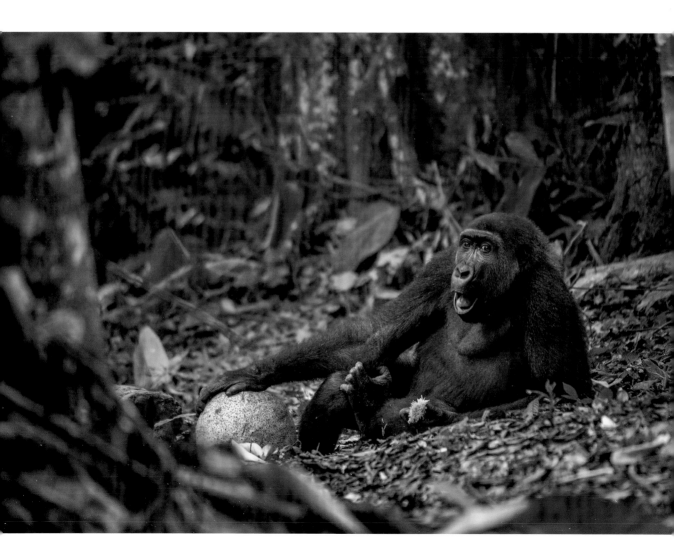

Stuck in

Ashleigh Scully

USA

Deep snow had blanketed the Lamar Valley in Yellowstone National
Park, and the day was cold and overcast. This female American
red fox was hunting beside the road, stepping quietly across the
crusty surface of the snow. Every so often she would stop, stare,
tilt her head from side to side and listen intently for the movement
of prey – most likely a vole – beneath the snow. Ashleigh was
also poised, her camera lens resting on a beanbag out of the
back window of the car. Just as the fox came parallel with the car,
she stopped, listened, crouched and then leapt high in the air,
punching down through the snow, forefeet and nose first and legs
upended. She remained bottom-up for about 10 seconds, waving
her tail slightly back and forth before using her back legs to pull
out of the hole. Ashleigh, who has been photographing foxes for
many years, though mostly near her home, captured the whole
sequence. 'It was funny to see but also humbling to observe how
hard the fox had to work to find a meal. I really wanted her to be
successful.' Unfortunately, she wasn't. But then the image, says
Ashleigh, 'illustrates the harsh reality of winter life in Yellowstone'.

**Canon EOS 7D Mark II + 500mm f4 Mark II lens; 1/640 sec at f5.6 (+1.7
e/v); ISO 1000.**

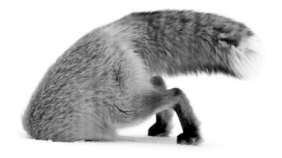

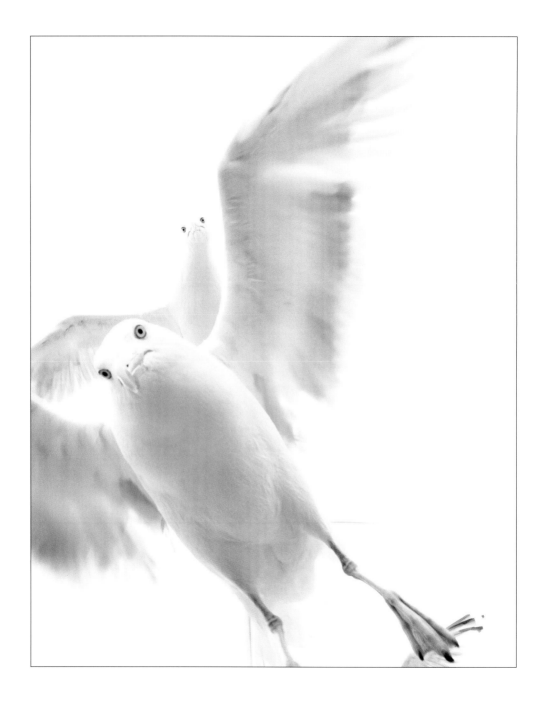

Photography is not only about creating outstanding images, it is also about being able to choose the ones that stand out, surprise and initiate an emotional response. It was especially nice to see that this young photographer was not only able to create this photograph, but also to recognize its artistic quality.

Jasper Doest

In the grip of the gulls

Ekaterina Bee

ITALY

Like all her family, five-and-a-half-year-old Ekaterina is fascinated by nature, and she has also been using a camera since she was four years old. But on the boat trip off the coast of central Norway, her focus was not on the white-tailed sea eagles that the others were photographing but on the cloud of herring gulls that followed the small boat as it left the harbour. They were after food, and as soon as Ekaterina threw them some bread, they surrounded her. At first she was slightly scared by their boldness and beaks but soon became totally absorbed in watching and photographing them, lost in the noise, wingbeats and colours of feet and beaks in the whirl of white. Of all the many pictures she took that day, this was the one she liked best because of the way the birds filled the white sky and the expression on the face of the bird furthest away: 'It looked very curious, as if it was trying to understand what was happening on the boat.'

Nikon D90 + 18–70mm f3.5–4.5 lens at 18mm; 1/320 sec at f11 (+0.7 e/v); ISO 400.

People's Choice

As well as the winning images chosen by the jury and showcased in the 2017 Wildlife Photographer of the Year Exhibition, the Natural History Museum has selected a further 25 images for an online global public vote, in recognition of the high standard of entries.

Hammerhead

Adriana Basques

BRAZIL/USA

Scalloped hammerhead sharks are generally found in the deep waters off Cocos Island, Costa Rica, where the currents are often fierce and the visibility unpredictable. It can be a tough dive with a big camera. Adriana had the advantage of a sunny day and good visibility with ample natural lighting. When a school of cottonmouth jacks came into view she waited to see if a hammerhead might appear. It didn't take long. This particular shark stayed just long enough for her to capture a full frame with the school of cottonmouths in the background, giving her the unique composition she had been searching for.

Canon EOS 5D Mark III + 16–35mm f2.8 lens; 1/160 sec at f5; ISO 640; Aquatica housing; Aquatica glass megadome.

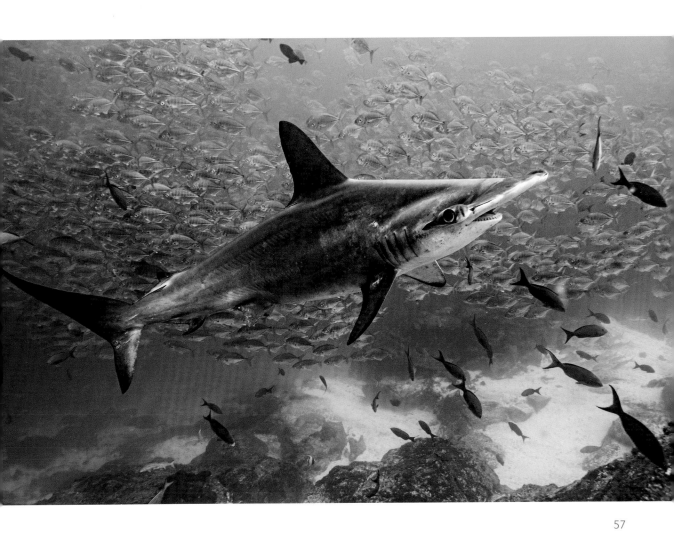

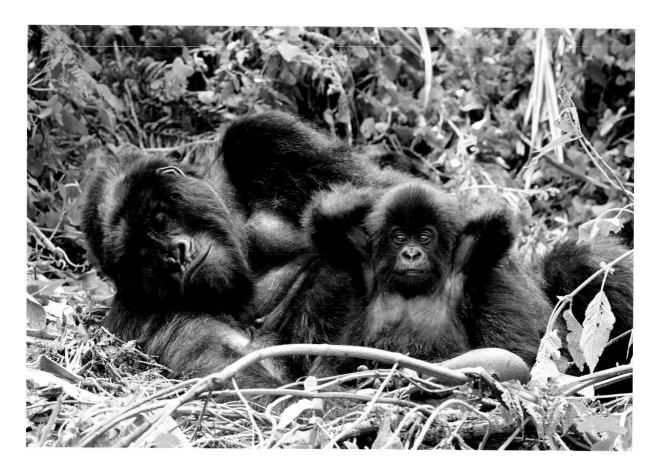

Kick back and chill

Alan Chung

USA

After more than two hours hiking with rangers in Volcanoes
National Park, Rwanda, Alan came across the 'Hirwa' family group
(meaning 'the lucky one'). This group of 16 mountain gorillas is led
by a single strong silverback. They were feeding on young bamboo
shoots and relaxing in a leafy open spot. Lucky for Alan indeed!

**Nikon D800E + Nikkor 80–400mm f4.5–5.6 lens; 1/250 sec at f11;
ISO 800.**

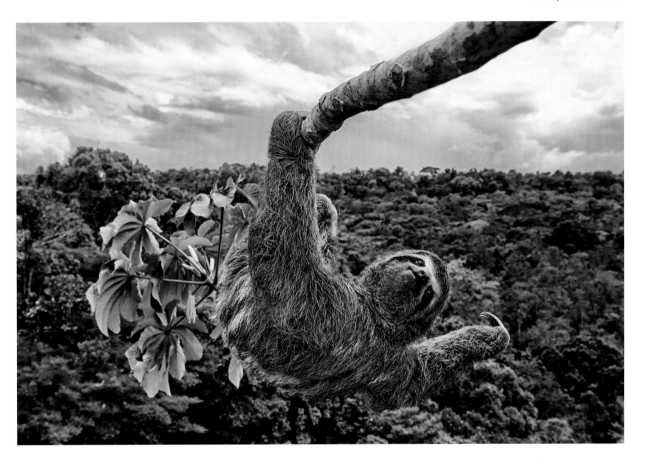

Sloth hanging out

Luciano Candisani

BRAZIL

Luciano had to climb the cecropia tree, in the protected Atlantic rainforest of southern Bahia, Brazil, to take an eye-level shot of this three-toed sloth. Sloths like to feed on the leaves of these trees, and so they are often seen high up in the canopy.

Nikon D800 + 24-70mm f2.8 lens; 1/800 sec at f11; ISO 640.

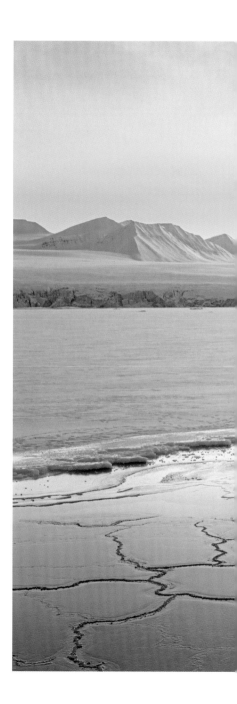

Land of snow and ice

Josh Anon

USA

The Arctic is beautiful all year-round, but in the late winter, when temperatures reach -30˚C (-22˚F) and everything is white and the sun stays low on the horizon, it's stunning. Josh was on a boat in a fjord across from Longyearbyen, Svalbard, Norway, and encountered this polar bear walking along the edge of the ice. She was curious, walking past the boat twice – just long enough for Josh to take a shot with her white coat glowing in the setting sun. After satisfying her curiosity, she silently walked off into the distance.

Canon EOS 5DS R + 24–70mm f2.8 lens at 50mm; 1/80 sec at f8 (+1 e/v); ISO 160.

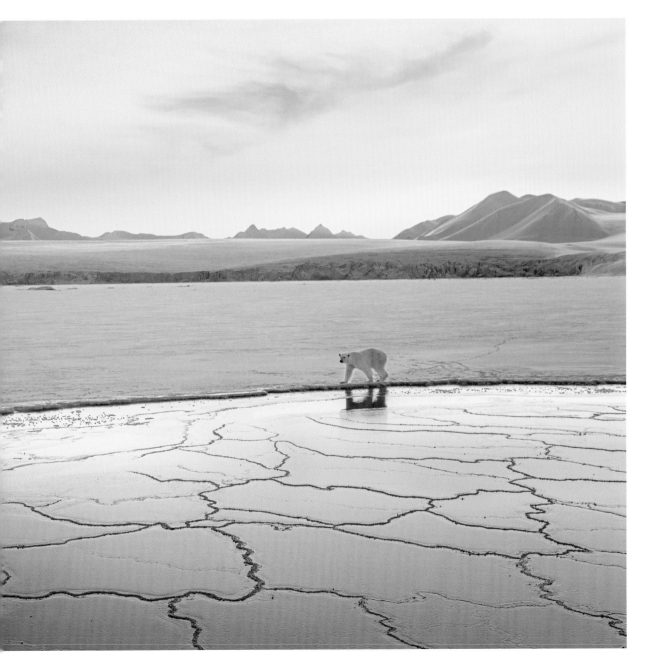

Grooming the descendant

Claudio Contreras Koob

MEXICO

This fluffy Caribbean flamingo chick is less than five days old
and is being preened by one of its parents in the Ría Lagartos
Biosphere Reserve, Yucatán, Mexico. Chicks remain in the nest for
less than a week; they then wander around the colony in crèches
and start to feed for themselves, although their parents still
continue to feed them for several months. The flamingo colony
is highly sensitive to human presence, so Claudio could only
approach the colony on all fours while hiding underneath a camo
throw-over.

**Canon EOS 5D Mark II + EF 300mm f2.8 lens + x2 extender; 1/500 sec
at f9; ISO 800; camo throw-over blanket.**

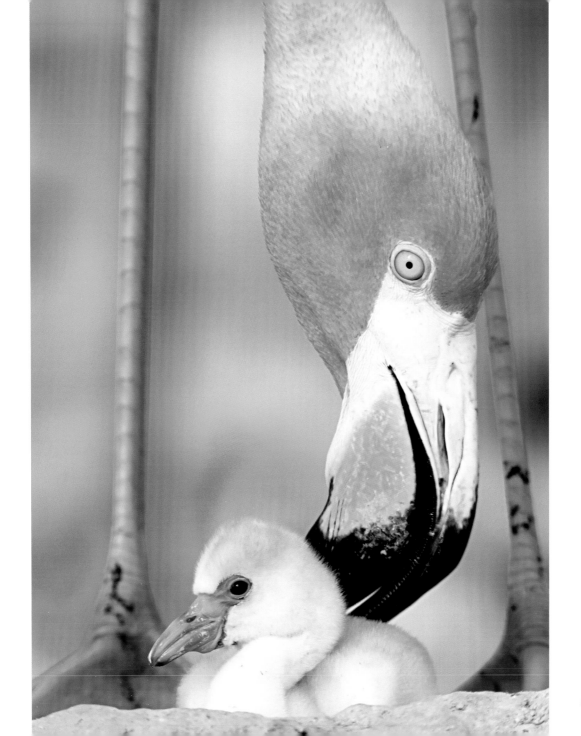

Neck and neck

David Lloyd
NEW ZEALAND/UK

Sometimes photographing large animals in isolation from their background can be difficult, especially if the background is too detailed. Luckily, David managed to capture the giraffes of Kenya's Maasai Mara National Reserve against a white, overcast sky, but he still opted to shoot a little closer and, adjusting the exposure, caught the intimate moment of a giraffe grooming its companion.

Nikon D800E + 400mm f2.8 lens; 1/1000 sec at f3.2, ISO 100.

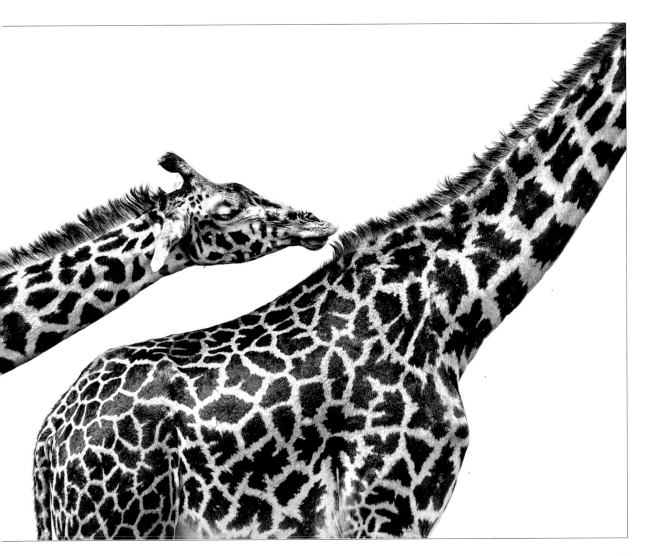

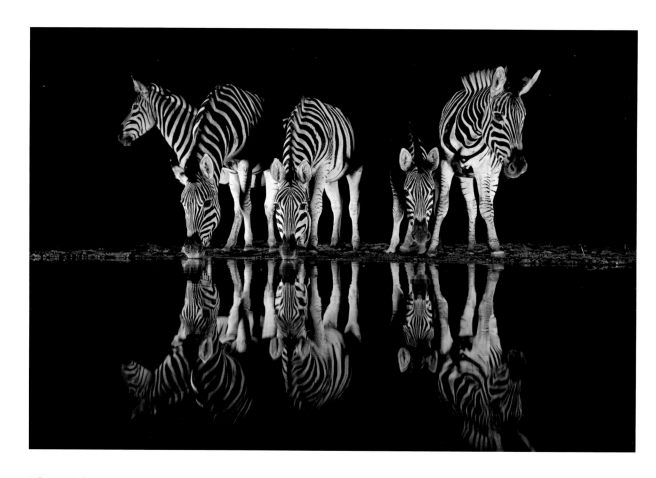

The nightcap

Charl Senekal

SOUTH AFRICA

For Charl, nothing beats the excitement and anticipation of sitting in wait at a waterhole during the dry season, knowing that anything can appear out of the darkness. The herd of zebra in South Africa's Zimanga Game Reserve surpassed his wildest wishes, and the still conditions resulted in a near-perfect reflection.

Nikon D5 + 24–70mm f2.8 lens at 38mm; 1/400 sec at f2.8; ISO 5000.

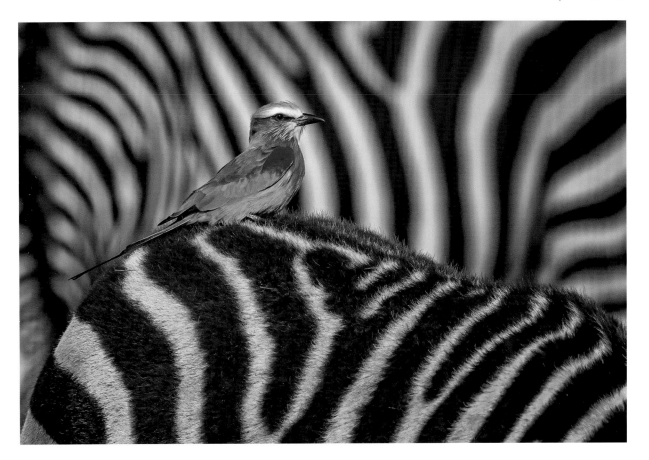

Roller rider

Lakshitha Karunarathna

SRI LANKA

Lakshitha was on safari in Maasai Mara National Reserve, Kenya, when he spotted an unusual sight – a lilac-breasted roller riding a zebra. Normally they prefer to perch high up in the foliage, but this roller spent an hour or more riding around and enjoying the occasional insect meal. Lakshitha waited for the surrounding zebras to form the perfect background before taking this tight crop.

Canon EOS 5DS R + 600mm f4 lens; 1/1250 sec at f7.1 (-0.67 e/v); ISO 125.

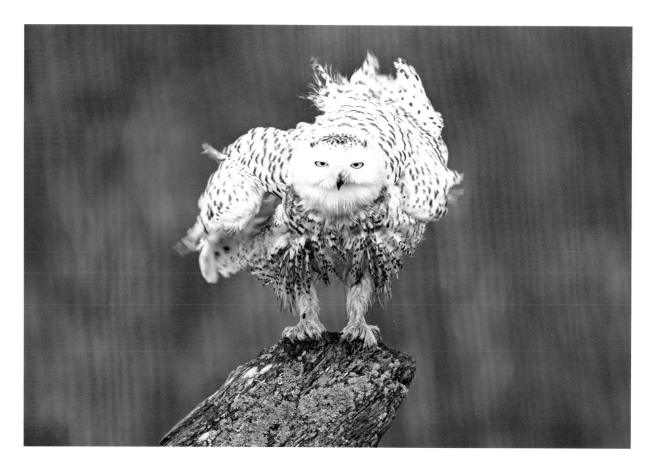

Shaking off

Connor Stefanison

CANADA

Approximately every five years an eruption of snowy owls makes its way down from the Arctic, where they breed, to the Pacific Northwest of North America, and congregates in areas like Delta, British Columbia. Connor captured this owl head-on as it was shaking off its feathers on a rainy winter day.

Canon EOS 1D Mark IV + Canon 500mm f4 lens + 1.4x teleconverter; 1/400 sec at f7.1; ISO 800; Gitzo tripod.

What are you looking at?

Jan Kolbe

SOUTH AFRICA

Jan spotted this small southern white-faced owl in a tree at a campsite in the Kgalagadi Transfrontier Park, South Africa. These owls have black-tipped 'ear' tufts and usually lay their eggs in the old nests of other birds. Jan was able to frame a shot of this striking bird looking down at him as it didn't seem bothered by the comings and goings of the campsite.

Canon EOS 7D + EF100-400mm f/4.5-5.6L IS USM lens; 1/250 sec at f10 ; ISO 400; Canon EOS 7D flash.

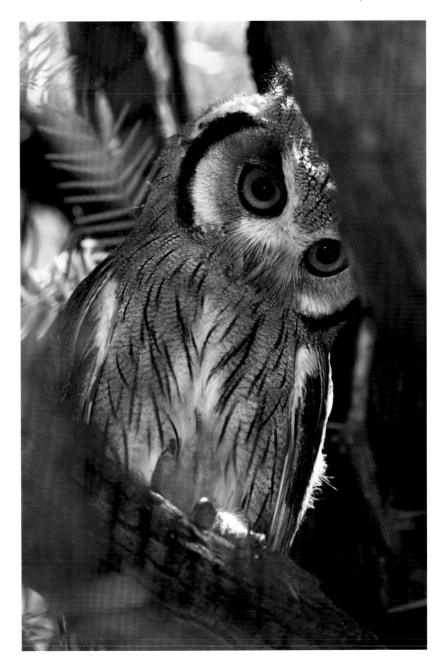

Warning wings

Mike Harterink

THE NETHERLANDS

Diving off Blue Bead Hole, St Eustatius, Caribbean, Mike used a slow shutter speed to capture the motion of this 'flying' gurnard. The fish's large pectoral fins are divided into a shorter forward fin with spines, which it uses to 'walk' around and to poke the ocean floor for food, and a larger wing-like part. The fins are usually held against its body but, when threatened, the fish expands them to scare away predators.

Nikon D200 + 12–24mm f1.4 lens at 12mm; 1/8 sec at f22; ISO 100; Seacam housing; two Seacam flashes.

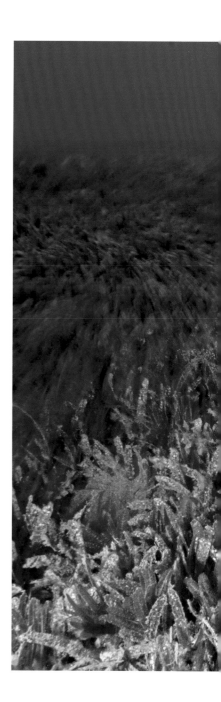

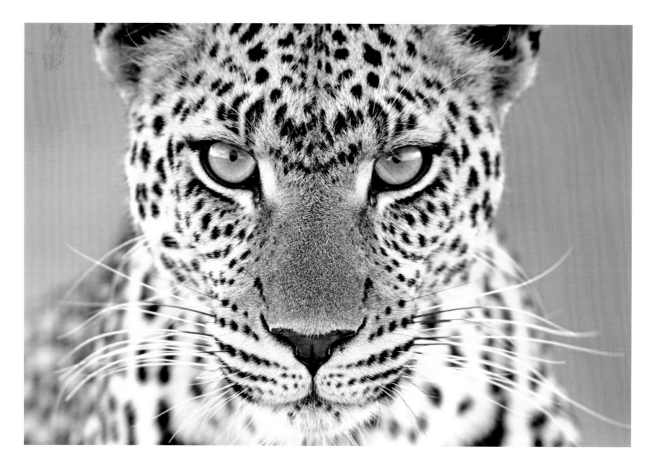

Leopard gaze

Martin van Lokven

THE NETHERLANDS

During a three-week stay in Serengeti National Park, Tanzania, Martin encountered this female leopard several times. Called Fundi by local guides, she was well known in the area. Late one afternoon, Fundi left the tree she was resting in and stopped by Martin's car, fixing him with her magnificent gaze.

Nikon D2X + 500mm f4 lens; 1/125 sec at f5.6 (-0.7 e/v); ISO 400; beanbag.

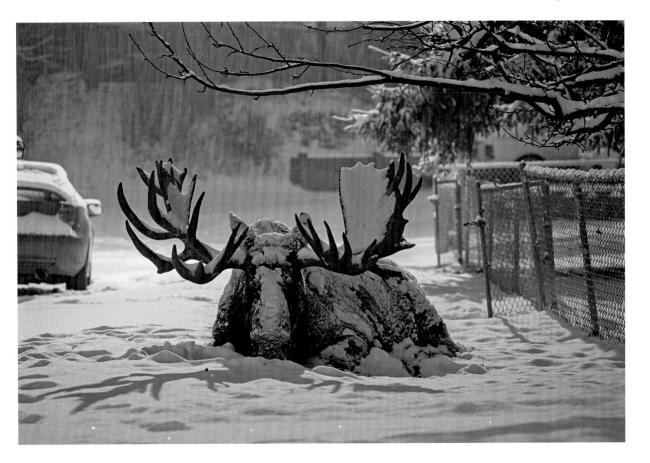

Settled in

Ryan Miller

USA

Moose are not strangers to the city of Anchorage, Alaska. This big bull is known as Hook, and Ryan knew from the previous year that he would be shedding his magnificent antler crown in the coming days. Ryan captured this scene in heavy snowfall as the rest of the city slept, and less than an hour later Hook shed his first antler.

Canon EOS 5D Mark III + 100–400mm lens at 135mm; 1/6sec at f5; ISO 2000.

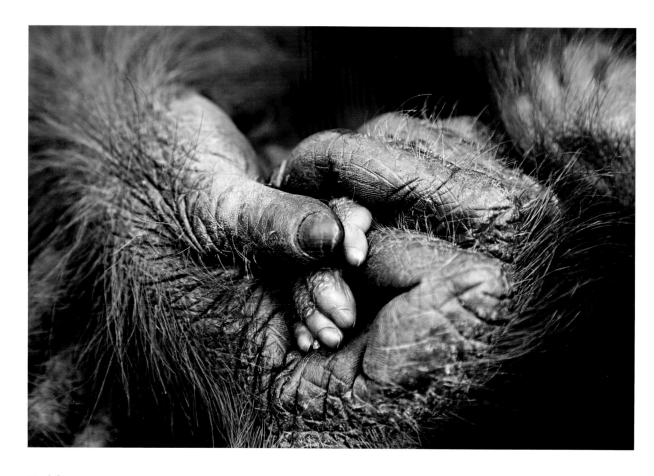

Holding on

Jami Tarris

USA

This close-up captures the touching moment an infant lays its small hand in the big hand of its mother. Jami took this photograph while she was in Borneo working on a story about the effects of palm-oil agriculture on orangutan habitat. Loss of primary rainforest is a serious threat to this already critically endangered species.

Canon EOS 1DS Mark III + Canon 24–105mm f4 lens; 1/250 sec at f5; ISO 400.

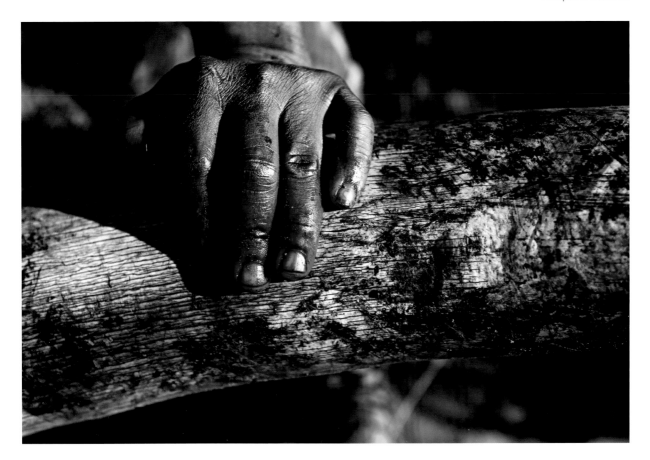

Bloody ivory

Peter Chadwick

SOUTH AFRICA

In a protected area of Zululand, KwaZulu-Natal, South Africa, a ranger's bloody hand rests on a heavily grained ivory tusk, also covered in the blood of an African elephant. The bull had to be destroyed due to a severe tusk infection that couldn't be treated. The tusks were removed to a place of safekeeping, where they were carefully catalogued in accordance with legislation.

Nikon D3S + Nikon 24–70mm f2.8 lens; 1/2000 sec at f4; ISO 200.

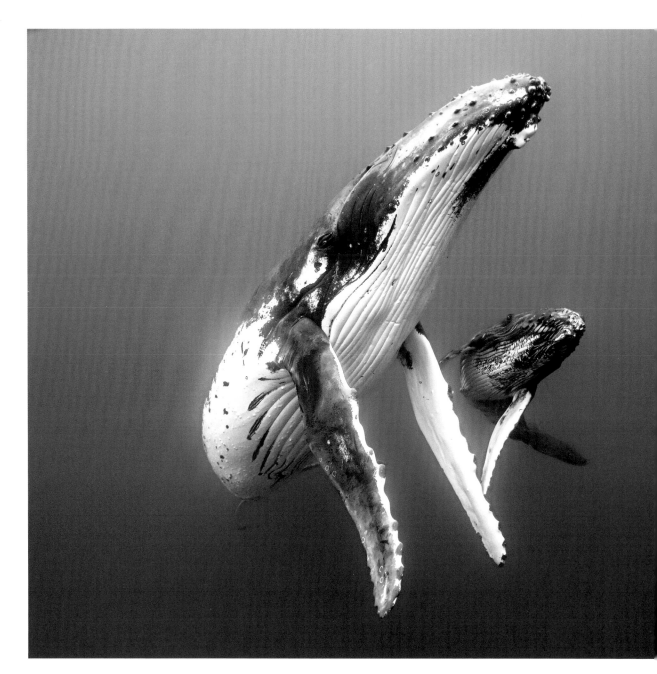

Elegant mother and calf

Ray Chin

TAIWAN

Every year from July to late October southern humpback whales migrate north from their Antarctic feeding grounds to give birth in the warm sheltered waters off Tonga. Ray encountered this humpback mother and calf peacefully floating in the plankton-filled water around the island group of Vava'u, Tonga. After Ray gently approached them, the giants swam a bit closer to have a look at him. While they made this elegant turn, Ray took the shot. He later converted the image into black and white which he felt represented the simplicity of the scene.

Canon EOS 5D Mark III + 16–35mm f4 lens; 1/100 sec at f6.3; ISO 250.

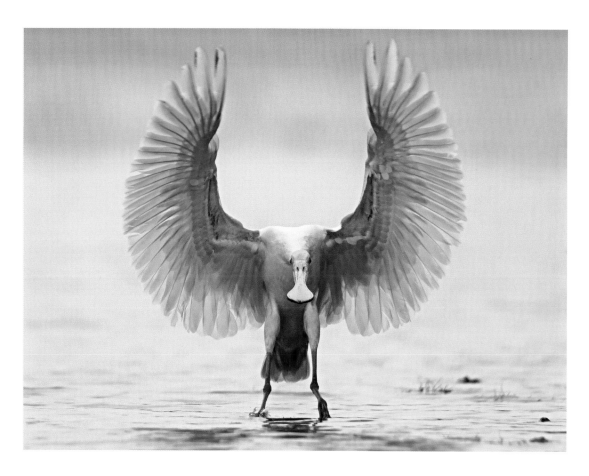

Reach for the sky

Steven Blandin

USA

Steven was taking pictures of a small group of adult roseate spoonbills in a rookery in Tampa Bay, Florida, when he noticed a newcomer flying in from afar. With just enough time to back up a few steps, Steven photographed the bird landing exactly square to his camera with its wings in a stunning symmetrical U-shape.

Canon EOS 7D Mark II + 600mm f4 lens; 1/2500 sec at f4; ISO 1000.

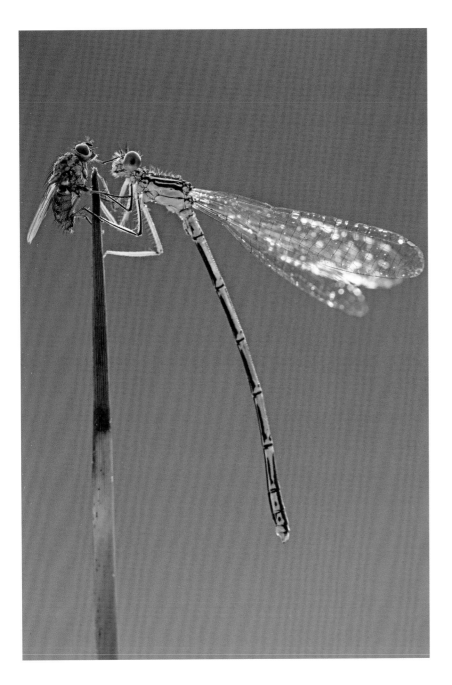

Beauty and the beast

Eva Haußner
GERMANY

Eva was trying to get the perfect shot of this unbelievably colourful blue featherleg dragonfly in Bad Alexandersbad, Bavaria, Germany, when suddenly a fly appeared. It clung to the dragonfly briefly before flying off, but luckily returned and gave her this unusual photo opportunity.

Canon EOS 5D Mark II + 180mm f3.5 lens; 1/640 sec at f5.6; ISO 1600.

Cleaning session

Jordi Chias Pujol

SPAIN

The protected waters around Carall Bernat, Medes Islands, Spain, are admired for their marine diversity and are popular with divers. Jordi knows of an area where sunfish visit in the spring to be cleaned by Mediterranean rainbow wrasses and other small wrasses. The sunfish adopt an upright position, signalling to the wrasses that they are ready. Jordi was able to approach and take a shot while the wrasses went to work picking off the skin parasites, which the sunfish are commonly afflicted with.

Panasonic Lumix GF1+ Panasonic Lumix 8mm lens; 1/40 sec at f8; ISO 100; two Inon strobes.

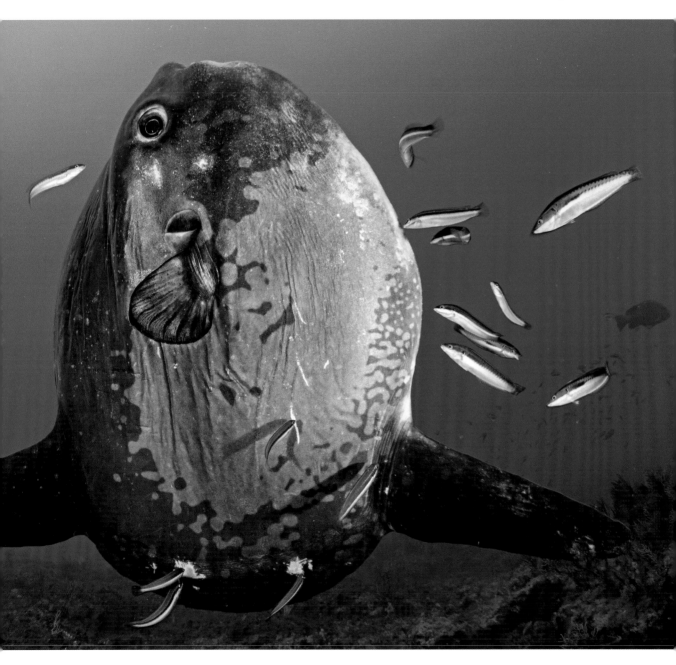

Pikin and Appolinaire
Jo-Anne McArthur
CANADA

Pikin, a lowland gorilla, had been captured and was going to be sold for bushmeat but was rescued by Ape Action Africa. Jo-Anne took this photograph as the gorilla was being moved from her former enclosure within a safe forest sanctuary in Cameroon to a new and larger one, along with a group of gorilla companions. She was first sedated, but during the transfer to the new enclosure she awoke. Luckily, she was not only very drowsy, but she was also in the arms of her caretaker, Appolinaire Ndohoudou, and so she remained calm for the duration of the bumpy drive.

Nikon D300 + Nikon 17–35mm f2.8 lens at 25mm; 1/100 sec at f3.2; ISO 1250.

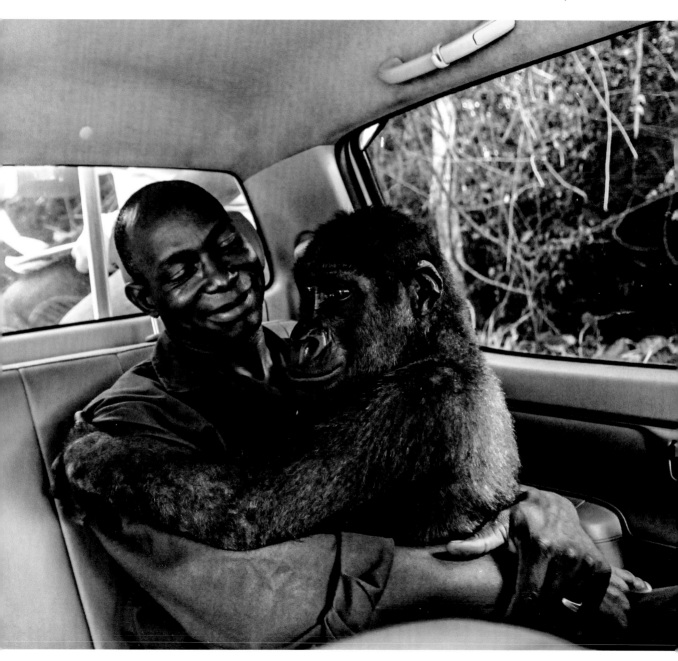

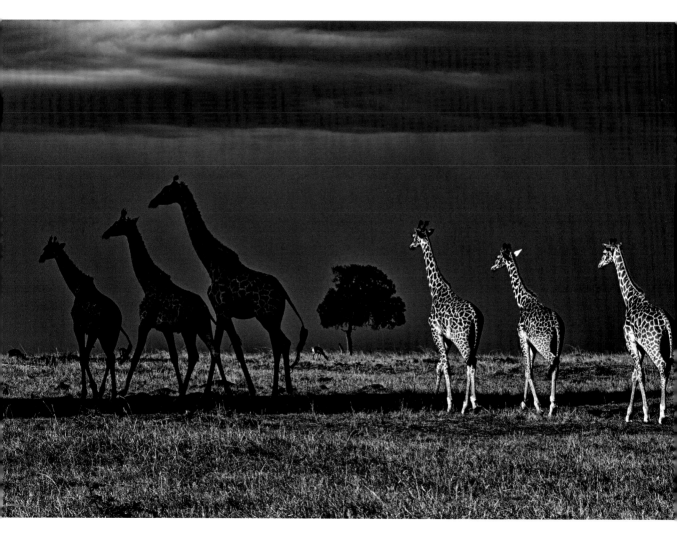

Dark side of the plains

Uri Golman

DENMARK

Uri had dedicated a whole week to black-and-white photography on the plains of the Maasai Mara National Reserve, Kenya, and had spent many days taking pictures of big cats. After a long day he suddenly came across six giraffes walking in formation. He decided to follow them for a while, and when three broke off and headed into the shadows he got this remarkable shot.

Canon EOS-1DX Mark II + Canon 70–200mm f2.8 lens at 180mm; 1/250 sec at f16; ISO 200.

Warm embrace

Debra Garside

CANADA

When polar bear mothers and cubs emerge from their dens in the early spring, the cubs stay close to their mothers for warmth and protection. Once the cubs are strong and confident enough, they make the trek to the sea ice with their mother so that she can resume hunting for seals. Debra waited six days near the den of this family, in Wapusk National Park, Manitoba, Canada, before they finally emerged. In the most challenging conditions she has ever faced, temperatures ranged from -35°C (-31°F) to -55°C (-67°F) with high winds, making it almost impossible to avoid frostbite and keep her camera gear functioning properly.

Nikon D4 + 800mm f5.6 lens; 1/2500 sec at f5.6; ISO 2000.

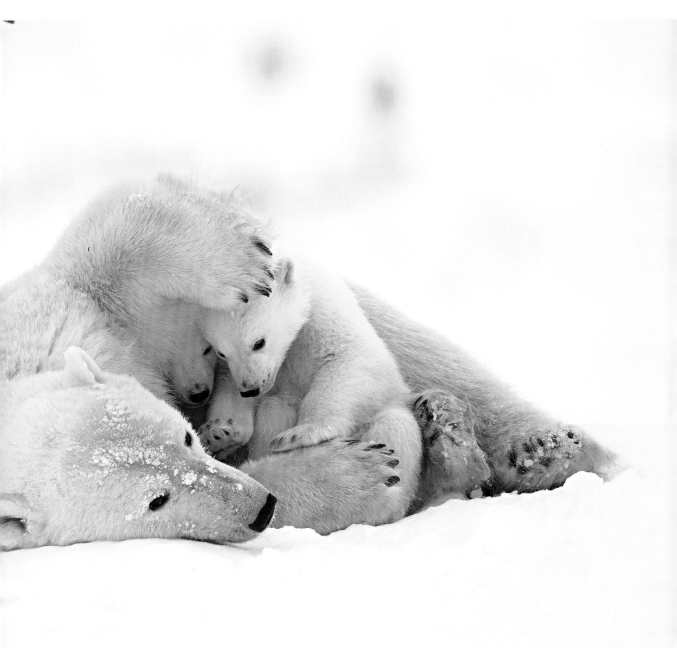

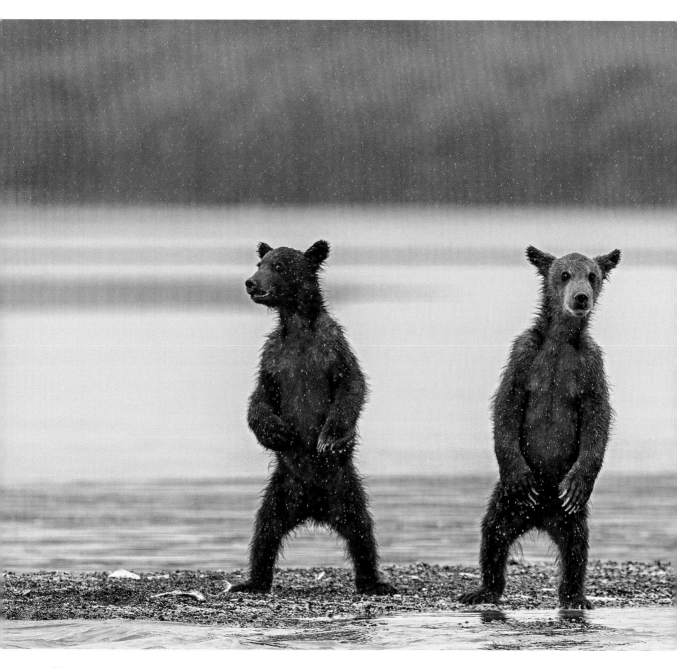

The brothers

Marco Urso

ITALY

Millions of salmon spawn each year at Kuril Lake in the southern part of the Kamchatka Peninsula, Russia, attracting large numbers of brown bears. Marco noticed how curious these two brown bears were and was able to capture the moment when they both stood up on their hind legs to watch what he was doing. The rain falling onto the lake added an extra atmosphere to the scene.

Fujifilm X-T2 + 50/140 mm lens; 1/500 sec at f8; ISO 800.

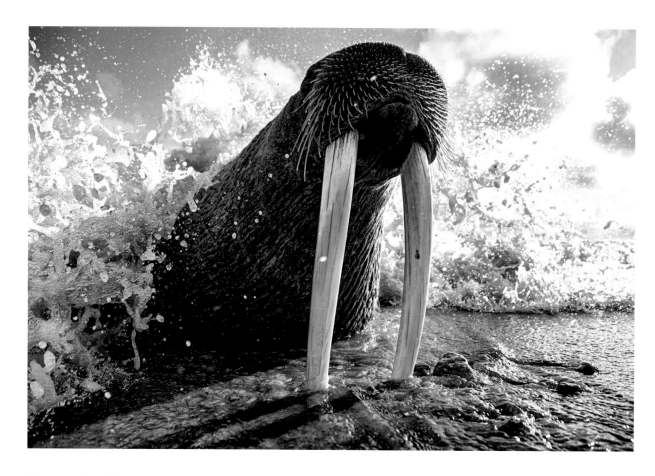

Dreams in the waves

Mike Korostelev

RUSSIA

Every autumn walruses swim to this rookery on Cape Vankarem, Chukotka, Russia. They see poorly and are guided primarily by sounds and smell. Walking along the beach away from the rookery, Mike came across this lone walrus sleeping on the shore with its tusks stuck in the sand, comically propping its head up out of the water.

Canon EOS 5D Mark II + 24–105mm lens; 1/2000 sec at f6.3; ISO 500.

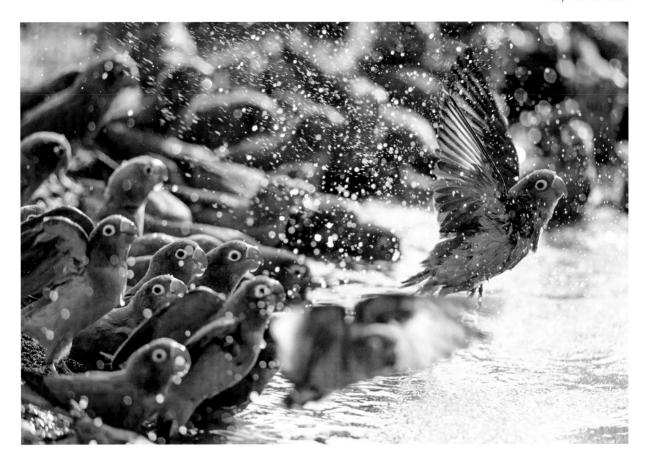

Pool party

Luke Massey

UK

As the drought in Zambia's South Luangwa National Park stretched on, the waterholes dwindled to pools. Flocks of Lilian's lovebirds congregated together and when the coast was clear they descended to the water's edge. They shuffled forward, taking it in turns to drink and bathe, as if on a conveyor belt.

Canon EOS-1DX + Canon 500mm f4 lens + 1.4x extender; 1/4000 sec at f5.6; ISO 1600.

Index of Photographers

60
Josh Anon
USA
http://joshanon.com

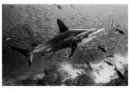

38
Laurent Ballesta
FRANCE
www.blancpain-ocean-commitment.com/
en-us#!/photographer/laurent-ballesta

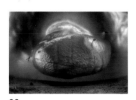

56
Adriana Basques
BRAZIL/USA
www.adrianabasques.com

54
Ekaterina Bee
ITALY
alessandrobee@hotmail.com

36
Anthony Berberian
FRANCE
www.anthonyberberian.photoshelter.com

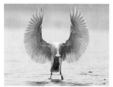

78
Steven Blandin
USA
www.bestbirdphotographytours.com

32
Dorin Bofan
ROMANIA
www.dorinbofan.com

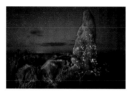

34
Marcio Cabral
BRAZIL
www.fotoexplorer.com

59
Luciano Candisani
BRAZIL
www.lucianocandisani.com

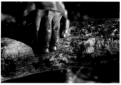

75
Peter Chadwick
SOUTH AFRICA
www.peterchadwick.co.za

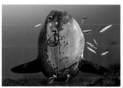

80
Jordi Chias Pujol
SPAIN
www.uwaterphoto.com
Agent
www.naturepl.com

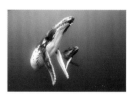

76
Ray Chin
TAIWAN
https://www.facebook.com/
RayChinImages/

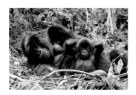

58
Alan Chung
USA
https://www.instagram.com/achungsf/

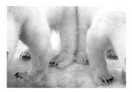

22
Eilo Elvinger
LUXEMBOURG
www.eilophotography.com

30
Justin Gilligan
AUSTRALIA
www.justingilligan.com

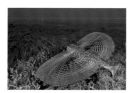

70
Mike Harterink
THE NETHERLANDS
mike@scubaqua.com

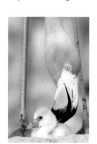

62
Claudio Contreras Koob
MEXICO
www.claudiocontreras.com

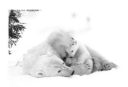

86
Debra Garside
CANADA
www.debragarsidephotography.com

84
Uri Golman
DENMARK
www.wild-explorer.com

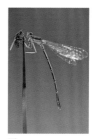

79
Eva Haußner
GERMANY
eva.haussner@web.de

20
Peter Delaney
IRELAND/SOUTH AFRICA
www.peterdelaneyphotography.com

40
Aaron 'Bertie' Gekoski
UK/USA
www.aarongekoski.com
Agent
www.scubazooimages.com

cover
Erlend Haarberg
NORWAY
www.haarbergphoto.com
Agents
www.natgeocreative.com/photography/
erlendhaarberg
www.naturepl.com
www.scanpix.no

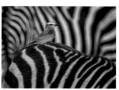

67
Lakshitha Karunarathna
SRI LANKA
www.LakshithaK.com

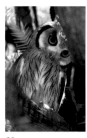

69
Jan Kolbe
SOUTH AFRICA
jankolbe17@gmail.com

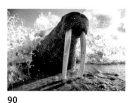

90
Mike Korostelev
RUSSIA
www.Mkorostelev.com

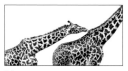

64
David Lloyd
NEW ZEALAND/UK
www.davidlloyd.net

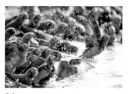

91
Luke Massey
UK
www.lmasseyimages.com

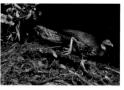

82
Jo-Anne McArthur
CANADA
www.weanimals.org

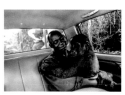

73
Ryan Miller
USA
www.explorealaskaphoto.com

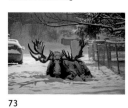

50
Daniël Nelson
THE NETHERLANDS
www.danielnelson.nl

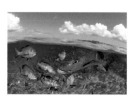

26
Gerry Pearce
UK/AUSTRALIA
www.australian-wildlife.com

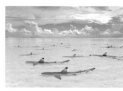

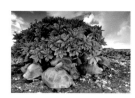

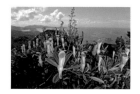

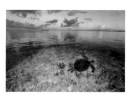

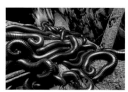

8–19
Thomas P Peschak
GERMANY/SOUTH AFRICA
www.thomaspeschak.com
Agent
www.natgeocreative.com

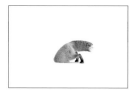

52
Ashleigh Scully
USA
www.ashleighscullyphotography.com

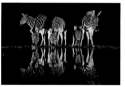

66
Charl Senekal
SOUTH AFRICA
www.zimanga.com

24
Brian Skerry
USA
www.BrianSkerry.com
Agent
www.natgeocreative.com

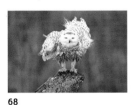

68
Connor Stefanison
CANADA
www.connorstefanison.com

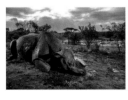

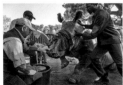

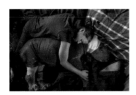

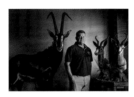

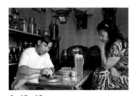

6, 42–49
Brent Stirton
SOUTH AFRICA
www.brentstirton.com
Agent
www.gettyimages.com

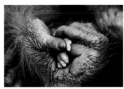

74
Jami Tarris
USA
www.jamitarris.com
Agents
www.gettyimages.co.uk
www.mindenpictures.com

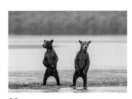

88
Marco Urso
ITALY
www.photoxplorica.com

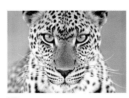

72
Martin Van Lokven
THE NETHERLANDS
www.martinvanlokven.com
Agent
www.mindenpictures.com

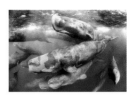

28
Tony Wu
USA
www.tonywublog.com
Agent
www.naturepl.com